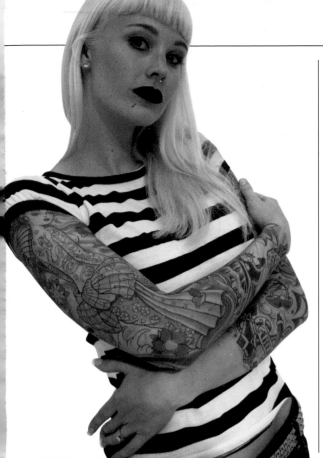

WELCOME TO BODY ART 2

IT'S AN EXCITING TIME FOR BODY ART, WITH ARTISTS EXPERIMENTING WITH NEW PROCEDURES AND AN ARMY OF FRESH INKED ICONS INTRODUCING THE WORLD TO THE POSSIBILITIES OF BODY MODIFICATION. JOIN US FOR A LOOK AT SOME OF THE MOST BREATHTAKING ACHIEVEMENTS.

CONTRIBUTORS

ASHLEY

Ashley is one of the UK's most respected photographers of alternative culture. Since taking up photography in 1989, Ashley's work, which "vacillates between the art and documentary genres", has been extensively published and selectively exhibited, and is held in both public and private collections.
Savageskin.co.uk

NEVILLE ELDER

Neville Elder started shooting for British newspapers in the 1990s, and moved to New York City in 2001. Today, he continues to shoot the weird and wonderful for *Bizarre* all over the USA. He's gentle and ginger, and likes swearing and drinking coffee in his spare time.
Nevilleelder.com

JOE PLIMMER

Joe Plimmer is a people snapper. He believes everyone has a story to tell, and a great photo within them. "I love my assignm⋯ says. "The magazi⋯ relationship with its readers, wh⋯ opportunities most photographe⋯
Joeplimmer.co.uk

RACHEL LARRATT

Rachel Larratt runs BMEzine.com, the biggest full-spectrum body modification online publication on ⋯chel will also be familiar ⋯er speaking role in Kevin ⋯and she's also an ⋯d rally racer.

Contents

BODY ART 2 CONTENTS

FEATURES

From eyeball tatts to self-amputees, and from mouth mods to pierced goldfish, we've got the latest developments in body art covered…

86

11

134

PICTURES: JOHN STONE, BMEZINE.COM, NEVILLE ELDER, ASHLEY

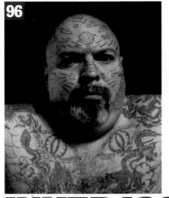

96

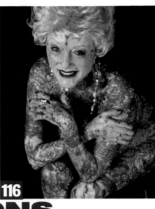

116

INKED ICONS

We interview some of the biggest names in body modification to get under their skin and understand what turns them on

Tatt Fact
Look out for the tattoo trivia scattered through this book

BODY MOD MASTERCLASS

These features, produced in association with BMEzine.com, cover some of the most important recent developments in body modding

YOUR TATTOOS

A selection of the best tattoos sent in to the pages of *Bizarre*

BODY ART 2

EDITORIAL
Editor David McComb
Deputy Editor Kate Hodges
Production Editor Nadia Shireen
Chief Sub Editor Eleanor Goodman
Senior Writer Denise Stanborough
Staff Writer Alix Fox

ART
Art Director Mike Mansfield
Picture Editor Tom Broadbent
Picture Researcher Emily McBean
Art Director At Large Dave Kelsall

COVER PHOTOS
Angell, Ashley, BMEzine.com, Lionel Deluy/Contour By Getty Images, Neville Elder, Lane Jensen, Joe Plimmer, Francis Traunig

CONTRIBUTORS
Photos: Angell, Ashley (Savageskin.co.uk), BMEzine.com, Capital Pictures, Lionel Deluy, Neville Elder, Gonzobear, Lane Jensen, Paul Sayce Tattoo Collection, PA Photos, Joe Plimmer, Rex Features, James Stafford, John Stone, Francis Traunig
Words: Emma Mendes da Costa (Tatt Facts), Marc Hartzman, Chris Nieratko
Special thanks: Darren Brooke, Dave Kinnard, Katie Brooke (repro)

ISBN: 9780857680815

Published by Titan Books
A division of Titan Publishing Group Ltd.
144 Southwark St.
London
SE1 0UP

First Titan edition: October 2011
10 9 8 7 6 5 4 3 2 1

Body Art 2 copyright © 2011 Dennis Publishing

Did you enjoy this book? We love to hear from our readers. Please e-mail us at: **readerfeedback@titanemail.com** or write to Reader Feedback at the above address.
To receive advance information, news, competitions, and exclusive offers online, please sign up for the Titan newsletter on our website: **www.titanbooks.com**

A CIP catalogue record for this title is available from the British Library.
Printed in China.

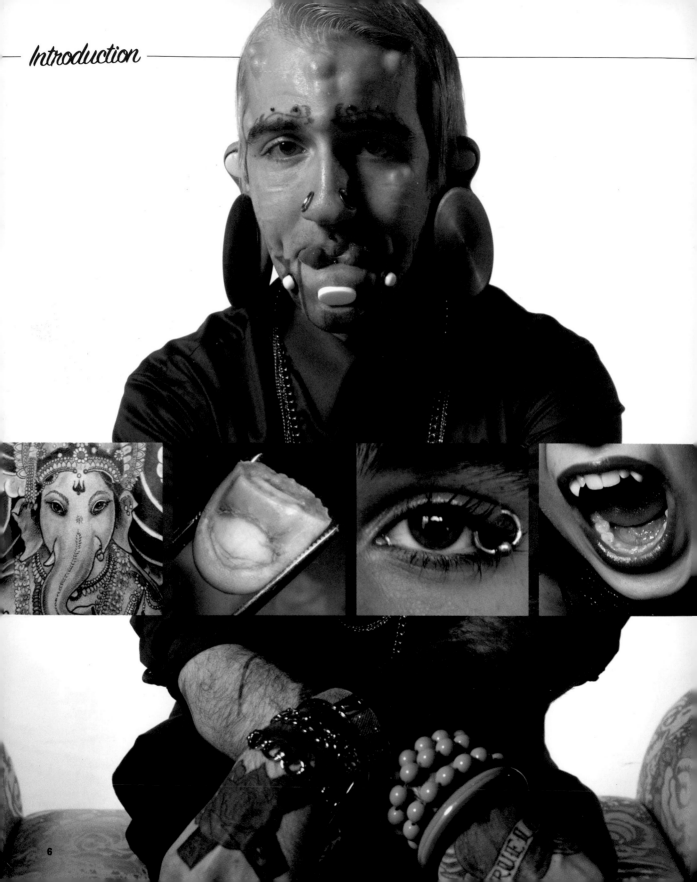

MORE PAIN

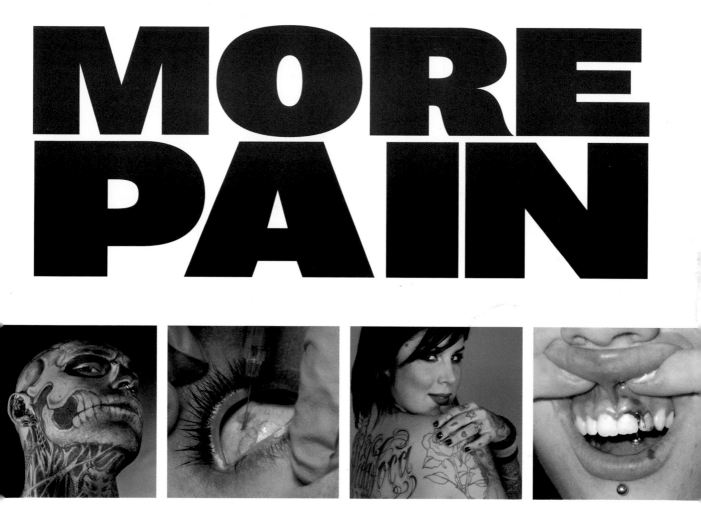

SINCE THE PUBLICATION OF *BODY ART*, THE WORLD OF BODY MODIFICATION HAS BEEN ROCKED BY A HOST OF INCREDIBLE NEW PROCEDURES AND A FRESH ARMY OF INKED ICONS. HERE'S A QUICK RUNDOWN ON THE MOST EXCITING DEVELOPMENTS... ➡

EYEBALL TATTOOS

↻ Using a lo-fi approach that makes most viewers wince, BME founder Shannon Larratt and a couple of his friends had their eyeballs tattooed. Read what happened on p28.

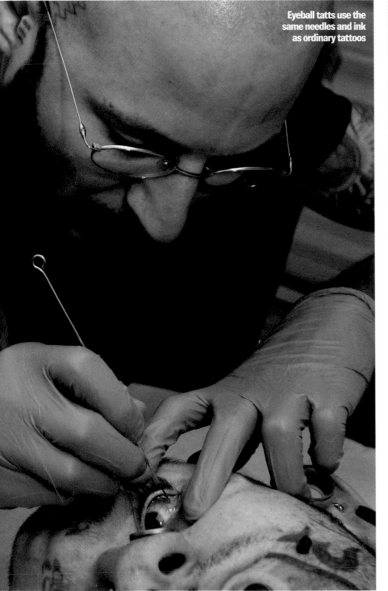

Eyeball tatts use the same needles and ink as ordinary tattoos

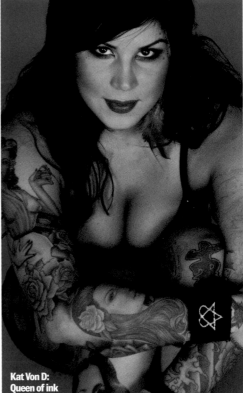

Kat Von D: Queen of ink

THE RISE AND RISE OF KAT VON D

◑ Kat Von D is one of the most famous tattoo artists in the world thanks to her appearance on TV show *Miami Ink*. Now the poster girl for contemporary body art, Kat's star continues to rise and rise, her reputation sealed by landing her own show, *LA Ink*. Read our exclusive interview on p42.

ZOMBIE BOY

⟳ One of the newest inked icons on the block, Rick – or Zombie Boy – is turning himself into the undead, with a terrifying bodysuit that's threatening to cover every inch of his skin. And when eyeball tattoos are more established, he's even planning to get his peepers blacked in. Meet him on p76, if you dare.

Tatt Fact

During the Vietnam War, conscripts of the Vietnamese army were tattooed with 'sat cong', which means 'kill communists'

Now experts can pierce almost any part of your body

EYELID PIERCING

🎧 As if eyeball tattoos weren't enough, now hardcore body modders are piercing their eyelids and hanging jewellery from the edge of their peepers. And despite what you may think, it's apparently no more uncomfortable than having a trapped eyelash. For all you need to know, check out our report on p152.

CONVERGENCE OF TECHNIQUES

🎧 Although there are dozens of ways to modify your body, we've noticed a trend for body artists to blend different techniques, with tattoos enhanced by subdermal implants or scarring mixed with ink. Take a look at p94 and how artists are using branding and tattoos to hide self-harm scars.

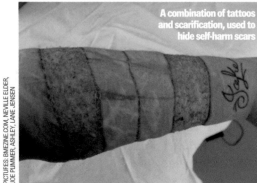

A combination of tattoos and scarification, used to hide self-harm scars

PAULY UNSTOPPABLE

🎧 Tattoo maniac Pauly Unstoppable's stretched nostrils have made him the talk of the internet. Turn to p56 to read a full interview with Pauly who, at the age of 23, is one of the most heavily modified people in the world. Ⓑ

Tatt Fact
Designer Marc Jacobs' numerous tattoos include a red M&M, SpongeBob SquarePants, and himself as a Simpsons character

FOR 15 YEARS, BMEZINE.COM HAS BEEN THE BIGGEST BODY
MODIFICATION WEBSITE IN THE WORLD, FOSTERING A
COMMUNITY FOR THE TATTOOED, PIERCED AND MODDED ➡

THE MOD
SQUAD

ince its launch in 1994, online magazine BME (Body Modification Ezine) has grown into the world's biggest body modification resource in any medium. But the Toronto-based site is more than just a collection of shocking pictures; instead, by offering first-person accounts, advice, warnings and reassurance relevant to everyone from first-time body modifiers to the body art hardcore, BME has become the heartbeat of the body modification community. It's how websites should be: an attempt to disseminate knowledge to further a common interest. Without it, the world would be a much duller place.

GROWING PAINS

Established by Shannon Larratt, the BME concept was partly inspired by the body mod legend's personal experiments. Shannon started piercing himself at the age of 10, mostly in places his parents wouldn't see, then began having permanent piercings and other procedures when he turned 17, photos of which brought the site to life when it first launched. Another important inspiration was the revered 1989 RE/Search book *Modern Primitives*, one of the first publications to examine the re-emergence and increasing popularity of tattooing, piercing, scarification and other body mod practices in contemporary Western society. Crucially, *Modern Primitives* illustrated that

Members of the modding community: Bloody and unbowed

THOUGH BANNED IN SOME COUNTRIES, THE INFLUENCE OF THE SITE IS AS STRONG AS EVER

Lopping off a toe in the name of BME

Tatt Fact

Japanese museums used to sponsor tattoos, so when the bearer died they could claim and display their skin

people who were into body modification were not alone, an attitude always echoed by BME, which has since evolved into a place where artists can share their experiences, talk about body art, and offer each other advice and support.

Although BME now has proper staff and gets thousands of hits each month, Shannon launched the site using his friend's computer and a selection of scanned photographs. However, in the fledgling days of the internet when users began to appreciate its community possibilities, it wasn't long before BME became the first stop for body modification on the web. And it's stayed that way ever since

TRAILBLAZERS

As well as the passion of its contributors and strong community it helped to foster, BME's reputation spread quickly because it was instrumental in the development of new practices. For the first time, this online resource allowed people to experiment and compare notes almost instantly. Many of today's most popular surface-piercing techniques came into being because like-minded individuals could interact with each other across huge geographical distances. ➡

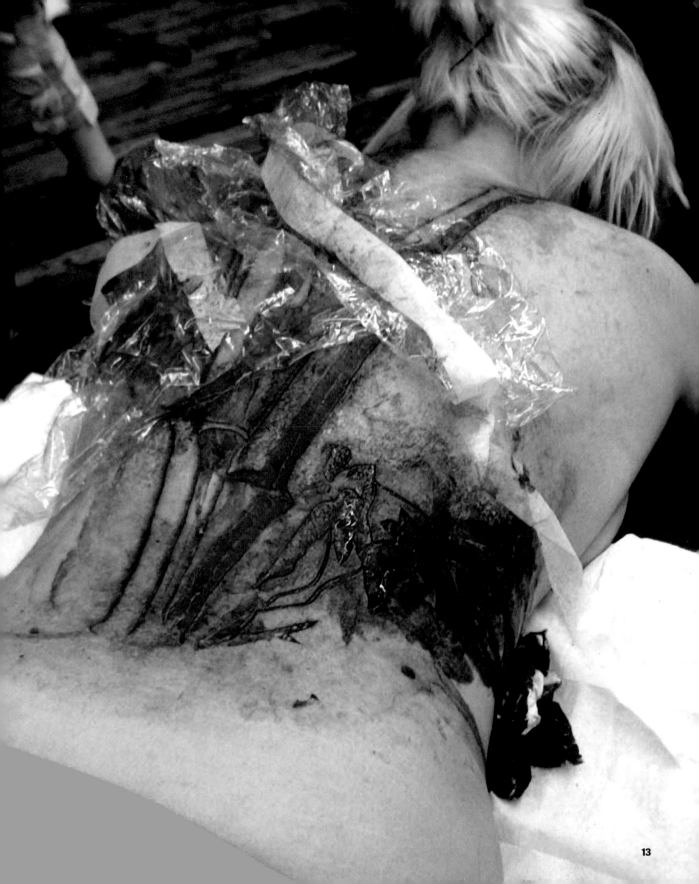

FIVE FAVOURITES

A CLUTCH OF THE MOST MEMORABLE BODY ARTISTS WHO GATHER AT BMEZINE.COM...

INDESTRUCTIBLE MAN

This German man pokes 30cm skewers into his side for kicks. Thanks to a highly developed immune system, he's never had an infection. His other hobby is extreme anal expansion.

PAULY UNSTOPPABLE

Pauly has the biggest stretched nostrils in the west. He started stretching his ears when he was just 11, and tattooed his face at 18. Read all about him in our exclusive interview on p56.

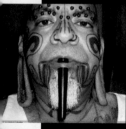

BEAR BIG EARS

Bear has the world's most stretched earlobes: at 140mm, he can fit his fist through the suckers. The 51-year-old says it took him years to expand his lobes to this diameter. He lives in Austin, Texas.

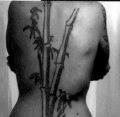

CORINNA

New Yorker Corinna's amazing back scarification – which features intricate shoots of bamboo carved into her flesh – was done by Brian Decker, who currently works at Pure Body Arts, New York.

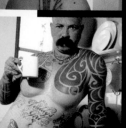

LINCOLN

A South African attorney, Lincoln had breast implants in 2003. He describes them as an "expression of sensuality". His partner, Mike, also has breast implants. Lincoln says, "I think guys with breasts are hot."

Suddenly, it didn't matter if only one in 100,000 people scattered across the globe was into body modification – they finally had a place to call their own.

As well as allowing people to perfect body mod techniques, BME was a constant source of inspiration, driving artists to investigate new and ever more daring body art. In fact, while *National Geographic* was once the only place where artists could learn about body modding and what was possible, BME allowed readers to see photographs of the work done by other contemporary artists across the world, in turn giving them the knowledge and creative spark to develop their own procedures. It's no exaggeration to say that the internet, and by extension BME, was instrumental in popularising body modification and making it the global industry it is today.

RAW POWER

BME is, for the most part, completely uncensored, and doesn't draw a distinction between different modifications – whether they're for aesthetic or sexual pleasure, for example. As well as the main body of

Tatt Fact
More subtle than most racist tattoos, a '100%' design expresses the bearer's desire for a 'pure' white race

YOU CAN READ ABOUT GENITAL-PIERCING, CASTRATION, AMPUTATION AND COCK TORTURE PLAY

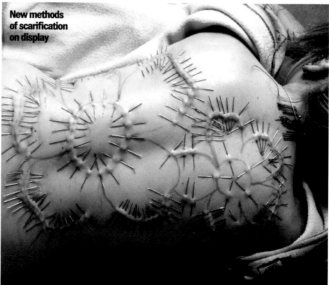

New methods of scarification on display

PICTURES: BMEZINE.COM, GARTH STAUNTON

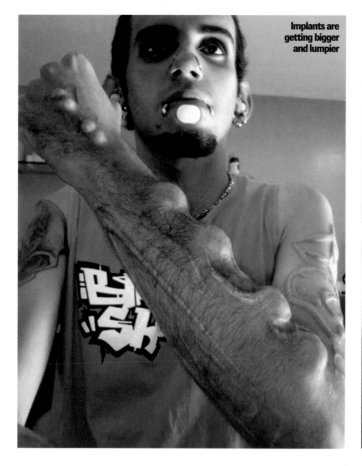

Implants are getting bigger and lumpier

A site with a little more bite

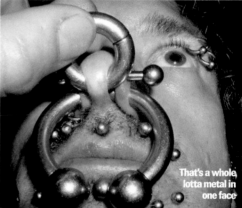

That's a whole lotta metal in one face

BME, there's also BME Hard and BME Extreme; the 'extreme' section is home, as you'd expect, to the most shocking modifications and procedures that don't have an overtly sexual theme, and that's where you can read about genital-piercing, vacuum-pumping, saline-injection, tongue-splitting, castration and amputations. BME Hard, on the other hand, is home to galleries with names such as 'cock torture play', 'blood, blood, blood', 'testicular torture', 'castration play', 'scrotal torture' and 'scrotal suspension', themes that still fall under the body modification umbrella, but have a sexual edge for contributors and viewers alike.

This inclusive ethos certainly helped BME become what it is today, but it's also caused the site some problems. BME is no longer hosted on US servers – it's been moved to Canadian servers, even though it costs more money – and some countries don't even acknowledge its existence. In 1999, Germany's Bundesprüfstelle Für Jugendgefährdende Medien (Federal Department For Media Harmful To Young Persons) banned BME as a "danger to the youth", and removed it from Google searches.

But while BMEzine.com remains controversial, its influence is as strong as ever. Hundreds of the site's users now have BME tattoos that are visible when you sift through the site's myriad galleries. And while tattoos are often an expression of self and individuality, in the case of the BME tattoos they're also an expression of unity, strength and community. 🄱

KEEP 'EM PEELED!

Look out for the Body Mod Masterclass columns produced in association with BME throughout the book. They cover important developments since the publication of the original *Body Art* book.

CARTOONS
INK INSPIRED BY CARTOON AND VIDEOGAME STARS

BOYKITTEN
Who did it?
Deryck at Tattooing By Fabio, Cambridge, UK.
What is it? A Cheshire Cat face, just above my four labia ring piercings.
Why did you choose it? The Cheshire Cat was my first tatt. I've always had an obsession with *Alice's Adventures In Wonderland*, and the Cheshire Cat is my favourite character.

MATTHEW K ROBINSON
Who did it? Some guy in Germany.
What is it? Johnny Bravo.
Why did you choose it? Because Johnny Bravo rocks! The tattoo speaks for itself.
What response do you get? "Awesome!"
How do you feel about it now? I still love it, but it needs a touch up. The guy who did it scared the shit out of me.

PETER D

What is it? Mario.
Why did you choose it? *Super Mario Bros 3* is one of the greatest games ever made.
What response do you get? Most people just point, grin and scream, "Mario!"
What other ink do you have planned? It's part of a full Mario sleeve, so I suppose I should add the Mushroom Kingdom.

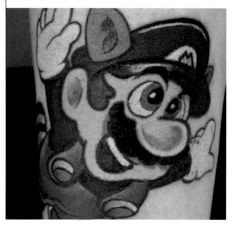

BROUSSE MYLÉNE

Who did it? I got it done in Last Resort Tattoo And Piercing, Limoges, France.
What is it? I have lots of tattoos, including skull cherries on my wrist, but this one is a sad bear.
Why did you choose it?
The sad bear is for a child I lost.
What response do you get? Some bad responses, but in general people love my tattoos.

GABRIEL VIGIL

Who did it? I've had work by lots of different artists, including Kat Von D and Helen Reid.
What is it? Ronald McDonald.
What response do you get? Most of my tatts are music-based, and the response I've had from people in the punk scene is great. I've had lots of children coming up to me to ask about my Ronald McDonald tattoo, though! ➡

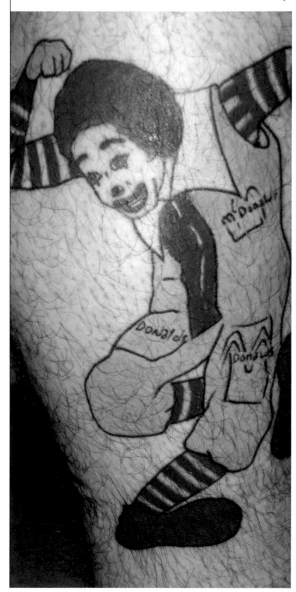

STEVE STILLWAGO

Who did it? Todd at Sinners And Saints Tattoo, Pittsburgh, USA.

What is it? Snoopy and the Peanuts gang.

Why did you choose it? I'm a huge Snoopy fanatic – and I always have been.

What response do you get? People say, "Wow! Usually tattoos show skulls, snakes and scary stuff. I really like yours – they're fun!"

MARK EDMONDS

Who did it? Stu Rollisson at King Arthur's Tattoo Studio, Scarborough, UK.

What is it? A Nintendo half sleeve, focusing on older Nintendo characters.

Why did you choose it? Gaming has always been a passion of mine, and I still remember playing the first *Donkey Kong*, back when Mario was Jumpman, and a carpenter!

JAYNIE BONES

What is it? Roman Dirge's Lenore character.

Why did you choose it? Because she's so cute and so dead!

What response do you get? Usually people just say, "Why?" But I don't care – it's my arm!

How do you feel about it now? I can't wait to get more tatts added and have a complete horror sleeve. I want more, more, more!

NAI DALLE

Who did it? Vix at Area 55 Tattoo Studio, Blandford, UK.

What is it? Wonder Woman.

Why did you choose it? Because Wonder Woman kicks serious ass, that's why!

What response do you get? People love it and ask who did it. I still love it. She's awesome! It's one of my favourite tatts.

GEM HARNETT

Who did it? Dave at Tattoo Magic, Southampton, UK.
What is it?
The cover of the Mindless Self Indulgence album *Frankenstein Girls Will Seem Strangely Sexy*.
Why did you choose it? I'm a big fan of Jamie Hewlett who did the art for this album. MSI are my favourite band, and their music has helped me through some pretty crappy days.

CLARE SARGENT

Who did it? Simon at DNA Tattoo, Newquay, UK.
What is it? Characters from Tim Burton's movie *The Nightmare Before Christmas*.
Why did you choose it? I love the film.
What response do you get?
Most people think it's cool.
What other ink do you have planned? I want to have a full sleeve with all the other characters.

SARAH WATSON

Who did it? Troy Johnson at Ink Link Tattoos And Piercing, Charlotte, USA.
What is it? Nintendo's Yoshi.
Why did you choose it? Nintendo is the only games system I've owned, and Mario adventures have always been my favourite. It's amazing how technology has advanced since the Atari days – now we have the iPhone and Nintendo Wii! ⑬

So you want to be a TATTOO ARTIST?

BEING A TATTOOIST MIGHT SOUND LIKE THE PERFECT JOB, BUT ONLY THE MOST DEDICATED NEED APPLY

WORDS **DENISE STANBOROUGH** MAIN PHOTO **ASHLEY/SAVAGESKIN.CO.UK**

Today, the tattoo industry is bigger than ever. As well as the arrival of TV shows *Inked* and *Miami Ink* in 2005, a huge number of celebrities sporting ostentatious tattoos has led to an increased interest in body art, as has the refinement of techniques that make it possible to produce flesh work that previous generations could only dream of. And with the sharp rise of interest in tattoos, it's no surprise that there's also been a swell in the number of people pursuing a career in ink.

However, becoming a professional tattooist takes years of dedication and a sharp imagination, essential qualities that any potential employer will look for. Over the next six pages, some of the biggest names in the tattoo industry reveal their top tips for achieving your dream, and getting one step closer to being the next Kat Von D or Chris Garver. ➡

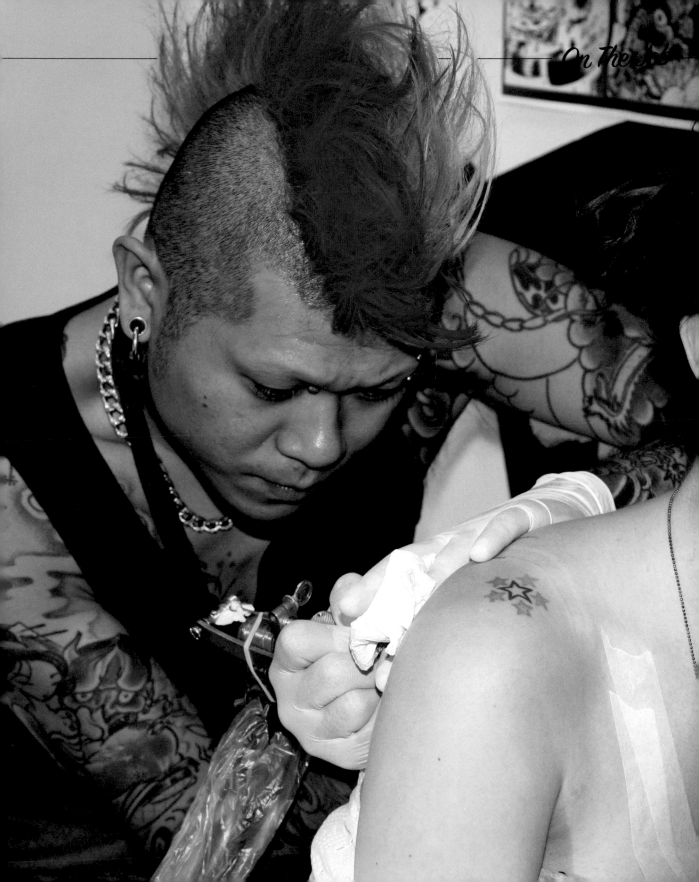

INK MASTER NO.1

JOE DRACHE

ACCENT TATTOO AND PIERCING 207 S STATE STREET, UKIAH, CALIFORNIA 95482, USA **WEBSITE** JOEDRACHEKICKSASS.COM AND ACCENTTATTOO.COM

Joe Drache is an award-winning tattooist with a "burning enthusiasm for art". He's been inking customers for over 20 years, and is currently branching out into 3D animation and digital tattoo flash design.

Tatt Fact

❝ Plenty of people want to be a tattooist, but only a fraction have the ability. But if you can draw on command and quickly, you're on the right track.

"It's hard to get an apprenticeship these days, and good studios expect complete dedication from anyone they take on. In fact, trainees are often treated like the shop bitch, and you should be happy about that because there are hundreds of guys who want your job. Be humble, be patient, watch everything and ask lots of questions.

"After tattooing 'ghetto style' (unlicensed, usually with homemade equipment) for eight years, I got a job in a 'real' tattoo studio. Ironically, this shop was totally unprofessional. For my interview I tattooed the owner, and the next day I was working on his clients! When starting out, make sure your studio has safe working practices, produces good work, and that the people you're working with are professional. You're going to be working with these people for a long time as a student – if you don't get along with them right away, it's only going to be worse down the line.

"But I promise, if you can make it through all these challenges, the rewards will be worth it. ❞

Joe's sinful work will definitely send him to hell!

JOE'S TOP TIPS

SAFETY IS PARAMOUNT
Tattooing is dangerous, and can be life-threatening because of cross-contamination. So always be fastidiously clean.

INKING ISN'T GLAMOROUS
There are plenty of ugly, smelly clients who want designs in strange places, and you won't get paid extra for tattooing a sweaty butt-crack.

TATTOOING CAN BE DULL
How will you feel about barbed wire designs after you've tattooed 12 miles of them?

CASH CAN BE A PROBLEM
I once worked five days with no pay, and I was commuting one hour each way. There are days when you sit in the shop all day then go home empty handed. No tattoos, no money!

TATTOOING IS A SIN
We're all going to hell, so you'd better get used to the fact!

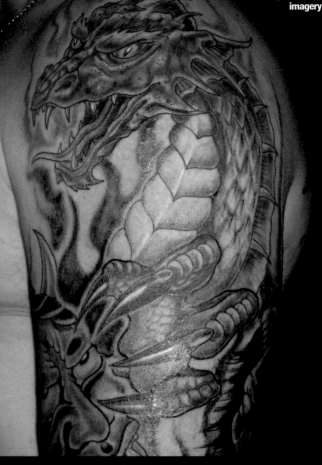

Lal's work uses classic, old school imagery

Lal tattooing soccer striker Emmanuel Adebayor

INK MASTER NO.2

LAL HARDY

NEW WAVE TATTOO 157 SYDNEY ROAD, MUSWELL HILL, LONDON, UK
WEBSITE NEWWWAVETATTOO.CO.UK
AND LALHARDY.CO.UK

Lal Hardy is one of the original old school inkers, with 30 years of needlework under his belt. Self-taught in the beginning, Lal is now secretary of the Association Of Professional Tattoo Artists.

❝ Although breaking into the tattoo trade is tough, nothing is impossible to a willing mind.

"When I started out it was difficult to find any information about becoming a professional tattooist, so I ended up with a rubbish starter kit and inking clients in my kitchen! Although I was full of enthusiasm, I was totally ill-prepared. These days, there are many training courses available, although not all of them are good. So shop around to see which course suits you best.

"Also, making it in the tattoo world doesn't happen overnight; you'll need a good personality, a great portfolio, a willingness to learn, a clean appearance, and the ability to accept criticism as well as praise.

"Also bear in mind that the public doesn't see the many hours of work that go into being a tattooist outside of the studio. You'll be drawing designs in your spare time, and after a busy day your head will be spinning. My last apprentice served many years of hard slog, but they've now opened their own studio in Hertfordshire, UK. If you're determined to make it, you will. ❞

LAL'S TOP TIPS

☑ STAY GROUNDED
Working in a tattoo studio isn't like how it's portrayed in TV shows. The reality is very different and you have to work extremely hard.

☑ TAKE CRITICISM
Be keen to learn and take any knocks on the chin. In the long run, you'll become a better tattooist if you can take criticism seriously.

☑ GET GOOD TRAINING
Train with a reputable studio that produces consistently high quality work.

☑ BE OPEN-MINDED
Studying other people's work and tattoo culture in different countries is a great way to broaden your mind.

☑ REMAIN CALM AND FOCUSED
Remember that you don't know it all, and you'll continue to learn throughout your entire career.

A selection of Matt's most stunning work

INK MASTER NO.3
MATT LUKESH

SEPPUKU TATTOO 2213A ROWLAND AVENUE, THUNDERBOLT / SAVANNAH, GEORGIA 31404, USA
WEBSITE SEPPUKUTATTOO.COM

Matt Lukesh opened Seppuku Tattoo with fellow tattooist Johnny DiDonna. He specialises in black and grey, horror and Japanese designs, and his ink has graced tattoo magazines, art galleries and posters across the USA.

❝ It's sickening how many people want to get into the tattoo trade at the moment – not because they have a burning desire, but because they think it's fashionable. Every time someone asks me for an apprenticeship, I look for an art background, drive and determination, and to see how many tattoos they have.

"My first experience of working in a professional tattoo studio was terrifying. After only a few days in the job, I unexpectedly had to work on this biker and had his entire crew gawping over my shoulder for four hours!

"The shit you see on television about tattoo studios is just self-glorifying garbage. I don't party – I just don't have the time. I work six days a week, and my one day off is normally spent catching up at home and preparing my art for the upcoming week. Real artists allow their work to dominate their lives.

"When you're deciding which tattooist to approach for an apprenticeship, ask yourself one question: Is the artist passionate about art or money? If the answer is cash, turn around and walk away. ❞

Tatt Fact
Surprisingly, there are no tattooing degree courses in the UK, and you should expect to serve a three-year apprenticeship

MATT'S TOP TIPS

BE READY TO WORK HARD

If you don't have the willingness to listen, learn and develop your art, then forget it – you're not cut out to be a tattooist. You'll also need to develop a thick skin and be able to handle criticism and lots of ball-busting.

SHOW YOU'RE GENUINE

With the huge interest in tattooing in the wake of TV shows such as Miami Ink, you need to show genuine artistic skill. Some studios look for art degrees, so be ready to prove your skill and ability to create unique designs.

STICK WITH A GOOD APPRENTICESHIP

It's tempting to move around, but shifting from one studio to the next could suggest you lack commitment. If an apprenticeship is helping you grow and developing your skills, stay put for a while.

DON'T EXPECT YOUR OWN STUDIO OVERNIGHT

I've been working for 11 years, but I still feel it's too soon to be a studio owner. There's a lot to be responsible for, including admin and finances, so don't try to open your own shop until you're a veteran inker.

ACCEPT THAT YOU'LL CHANGE

Being in the industry has toughened me up. You'll learn a lot about yourself, and it can make you humble, wary and thankful.

25

INK MASTER NO.4

FRIDAY JONES

XAC ANTHONY SALON AND SPA 140 WEST 19TH
STREET, NEW YORK, NY 10011, USA
WEBSITE XACANTHONY.COM

Friday Jones started her apprenticeship at the prestigious Inksmith And Rogers studio in Florida in the early 1990s, and has gone on to tattoo the likes of Robbie Williams and Angelina Jolie. Friday has won many awards for her tattoo work, and has been a member of the National Tattoo Association since 1994.

❝ Every kid wants to be a tattoo artist, but bringing in a sketchbook full of ballpoint doodles and asking for an apprenticeship doesn't cut it. Instead, it's best to present your work in a nice portfolio and mount 10 of your best pieces, while still being prepared to sweep the floor and clean toilets for 12 months if you get in. Young people often see tattooing as a freedom-driven industry, which is tremendously appealing. But that isn't the reality.

"When you're looking for an apprenticeship, try to find an artist who can take you or leave you. If a studio owner wants to get you to work right away, they're probably desperate to find someone who'll earn them cash – and a desperate artist is a questionable artist. Referral is the best solution; if you see a tattoo on the street you admire, be ballsy and ask that person about where they got it.

"Women working in the tattoo industry have come a long way in recent years, but they're pretty arginalised. It's a regrettable situation, but female artists need to work harder to prove themselves. ❞

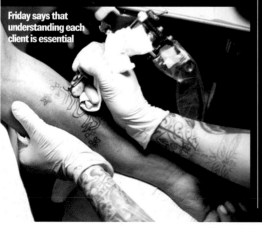

Friday says that understanding each client is essential

Remember, don't drink when getting inked!

Tatt Fact

FRIDAY'S TOP TIPS

1: LEARN TO DEAL WITH PEOPLE

Tattooing is a service industry, so don't waste time geeking out alone out with your computer or sketchbook. Tattooists are there to serve real customers.

2: REDRAW CLASSIC DESIGNS

Study the work of old school masters such as Sailor Jerry and Ed Hardy – tattoo masters will respect your knowledge.

3: PRESENT A PORTFOLIO

Treat an interview at a tattoo studio the same way as you'd treat any job, and be professional.

4: LOOK AT THE BIGGER PICTURE

Don't just focus on the design aspect of tattooing – learn about salesmanship and blood-borne pathogens. Reading up on these subjects will make you an asset to any studio.

5: TRY TO GET INSIDE YOUR CLIENT'S HEAD

Start asking your friends about their hopes, dreams and important events in their lives, then draw designs based on those conversations, just for fun. If you do it right, you'll see your work striking deep chords with the people you care about, and that will make you a great artist.

WOODY

WOODY'S TATTOO STUDIO
22 OCTAGON PARADE, HIGH WYCOMBE, UK
WEBSITE WOODYSTATTOOSTUDIO.COM

Woody first developed his tattooing skills by inking his own legs and now, 17 years on, he still hasn't looked back. An award-winning artist, Woody is also a regular face at tattoo conventions across the UK.

❝ Now more than ever, tattooing is perceived as a desirable profession and an ideal job. There are apparently no hard or laborious tasks involved, no strict bosses or harsh regimes. The pay is potentially great, and the dress code and hours of work are easy. However, it's precisely this view that attracts a large amount of fantasists to the industry who'll never be able to realise their ambitions.

"There isn't a structure in place within the tattoo profession for apprenticeships Therefore, the tattoo world tends to be naturally selective – when the realities of a demanding career become clear, the less able quickly fall by the wayside. And while many professional tattooists claim they had an apprenticeship, if you question them closely it soon becomes clear that this is an exaggeration. Learning about tattooing inevitably involves self-motivation, since this is the only effective course open to the masses who want to become tattooists.

"Personally, I look for positive, creative individuals who are sincere in their goals. When talking to a potential tattooist, I demand to see a portfolio which shows genuine development in their work. Absolutely no drugs, alcohol or problem people are allowed. A pleasant, honest demeanour is what I look for. If you don't have work experience, the next best thing is a portfolio showing outstanding creativity. ❞ Ⓑ

WOODY'S TOP TIPS

▥ BE REALISTIC
Forget the myth that becoming a tattooist leads to fame and riches. You don't need to be a tattooist to get any of this, and it's not a rescue package for a faulty psychology.

▥ WORK WITH PEOPLE, NOT FOR THEM
Always aim to work for your customer's best interests, but don't forget your own.

▥ LOOK FOR INSPIRATION
Look outside the tattoo world for inspiration. Learn from alternative arts to expand your potential.

▥ REMEMBER WHAT IT'S LIKE TO BE THE NEW KID
In the later years of your career, don't turn into the rude tattooist who wouldn't help you out.

▥ BE AWARE OF OTHERS
Surround yourself with positive people, rather than negative types who'll affect your art adversely.

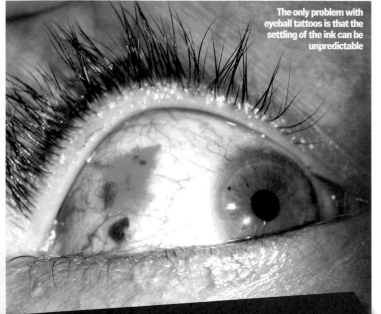

The only problem with eyeball tattoos is that the settling of the ink can be unpredictable

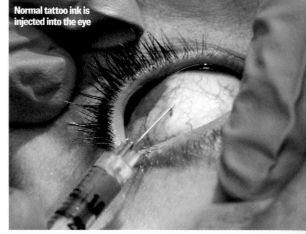

Normal tattoo ink is injected into the eye

According to those with eyeball tatts, the procedure doesn't hurt

Body Mod Masterclass No.1
EYEBALL TATTOO

GETTING YOUR PEEPERS PAINTED IS BECOMING EVER MORE POPULAR WITH THE MODDING HARDCORE

*J*ust when you think you'll never be shocked by a body modification ever again, along comes the eyeball tattoo. Yes, the *eyeball* tattoo. People really are getting their peepers inked, and in more or less the same way you'd get any other part of your body tattooed.

Along with two of his friends – Pauly Unstoppable and Josh – Shannon Larratt, founder of BMEzine.com, got his eyeball tattooed. And although Shannon is heavily modified and claimed it wasn't "a big deal", he did concede to feeling a little trepidation. "I'd much rather a bunch of people had done it before me," he says, "but what choice did I have?"

Shannon says they adopted "a really simple, lo-tech approach" to the procedure. His eye was held open, using a forefinger and thumb, as the pigment – which is

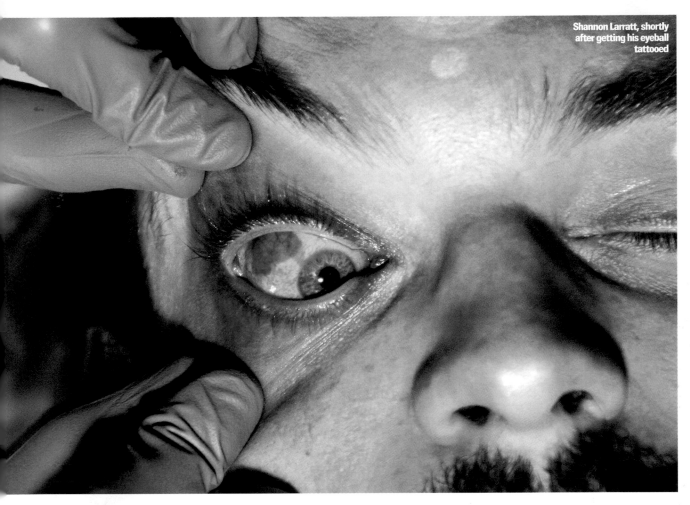

Shannon Larratt, shortly after getting his eyeball tattooed

the exact same type you'd use in a regular tattoo – was injected under the top layer of his eyeball using a needle. Although the procedure sounds toe-curlingly dangerous, Shannon's adamant it isn't. "The eye is very resilient," he says. "You can put almost anything in it. After all, your eye's actually designed to be able to handle contaminants being there."

Shannon says the procedure didn't hurt and he's had no ill effects to his sight. The only problem seems to be in how the ink settles; with Pauly's eye tattoo, most of the ink seeped away and it's now hard to see that any work was done. Shannon's eye tatt is clearly visible if you look at him side-on, but Josh had the best result because the ink was injected towards the front of his eye. Shannon plans to have more injections to give the tattoo a more solid appearance, and then have his other eye done.

PIGMENT WAS INJECTED UNDER THE TOP LAYER OF THE EYEBALL

Recently, documents dating back to the late 19th century have been discovered that refer to eyeball tattoos, when it was offered as part of corrective surgery or as a cosmetic practice to change the colour of the eye.

"It's one of the oldest forms of tattooing," says Shannon. "Medical reports from over 100 years ago say it's safer than regular tattooing. That's one reason we felt secure moving forward with this – if they could do it in 1900, we should be able to do it now." Ⓑ

PICTURES: BMEZINE.COM

29

The
Inkredibles

IN *BODY ART 2*, YOU'LL MEET THE BIGGEST NAMES IN BODY MODIFICATION. BUT FOR NOW, HERE ARE A FEW OF OUR ALL-TIME FAVES...

ETIENNE DUMONT
THE HUMAN RAINBOW

Etienne Dumont is 60, lives in Geneva, Switzerland, and works as a newspaper critic.

When did you start collecting ink?
I got an eagle on my arm in 1974. Then I decided to get my back covered in coloured ink, which took two years.

Why did you decide to tattoo your face?
I had a small white Tā moko (Maori marking) on my chin in 1999. My cheeks followed in 2001, my nose in 2002 – both were simple black lines. Then I had my skull fully inked to match the rest of my body, which was completed in 2005.

How did it feel having your head tattooed?
I felt nothing, but the nose was painful and bled a lot. The worst thing with all of them is that you're partially inked for a long time. I'm always impatient to see the final result.

What kind of reactions do you get?
It's not too bad. I was attacked by a lunatic once, but he was on drugs and thought I was the devil. My bags never get checked at airports. I'm so visible people don't expect me to carry a bomb.

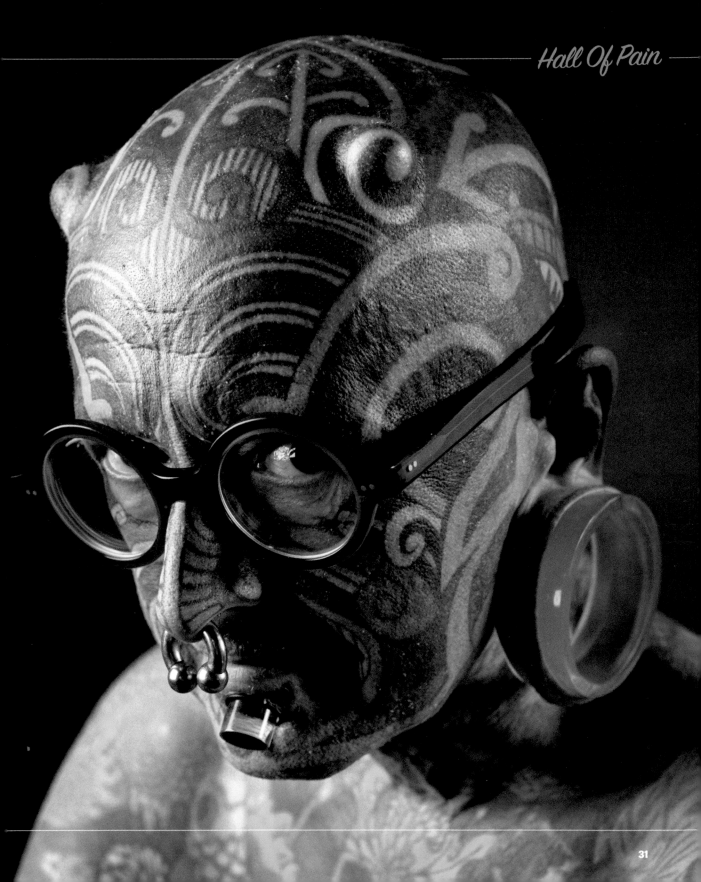

PICTURE: JAMES STAFFORD

Dennis Avner

CURL UP WITH CATMAN

With his striking tiger stripes, fangs and droopy synthetic whiskers, Dennis Avner is one hot pussy. Once upon a time, 'Catman' was advised by a Native American chief to "follow the way of the tiger". He did this racking up an impressive list of body mods; face and body tatts, facial transdermal implants, surgical ear pointing and silicone injections to his chin, cheeks and lips. He now wants to have his collection of tiger pelts grafted to his skin to become the ultimate cat-human hybrid. Stalkingcat.net

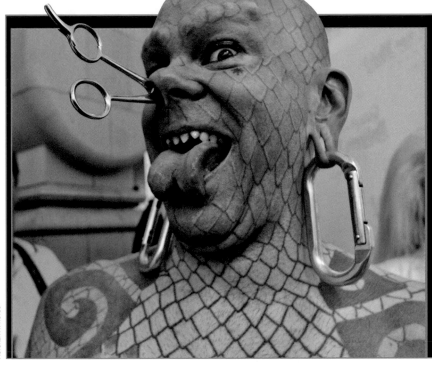

PICTURE: PA PHOTOS

LIZARDMAN
HE'S OFF THE SCALE!

Erik Sprague turned himself into a lizard after an idea he had at college. "I wanted to use body mod procedures for an art piece to explore the idea of what it means to be human from a linguistic standpoint," he says. "The reptilian theme made for a good fit with the other plans I had for stuff like my tongue and teeth." After four years of planning, Erik began his tattoo journey in 1994 and estimates he's endured around 700 hours of inking. Lizardman now performs his own live sideshow and has an impressive repertoire of acts, including live stomach pumping, groin suspension and shooting darts from his nose.
Thelizardman.com

CINDY RAY
AUSTRALIA'S FIRST LADY OF TATTOO CULTURE

Cindy Ray (real name Bev Robinson) was a 19-year-old office clerk when she answered an ad from a photographer looking for models. Harry Bartram persuaded Bev to get inked and travel Australia with the circus. Billed as 'Miss Technicolor', Bartram earned a crust off the back of Bev's success, while she was oblivious to her growing league of fans and role as a tattoo scene figurehead in the 1960s. After two years, Bartram disappeared, and Bev pursued a career as a tattooist. She opened a studio called Moving Pictures in a town near Melbourne, where she works to this day. ➡

PICTURE: PAUL SAYCE TATTOO COLLECTION

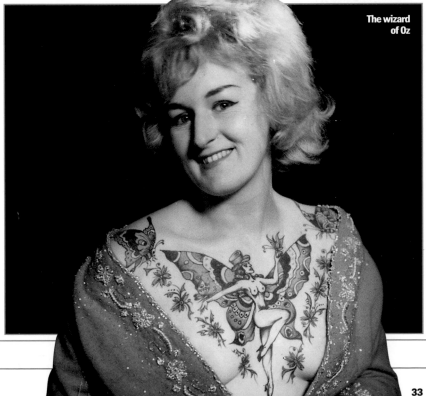

The wizard of Oz

Horace Ridler,
self-made oddity

34

THE GREAT OMI
THE LEGEND OF ZEBRA MAN

Born in 1886, Horace Ridler's upbringing was a privileged one. His father died when Horace was young, leaving him a bundle of cash that he squandered on a hedonistic lifestyle. In need of money, he decided to exhibit himself as a sideshow attraction. Undergoing over 150 hours of needlework, Horace emerged with zebra-like stripes all over his body. As The Great Omi, he enthralled audiences with 'true' stories of being kidnapped in New Guinea and tortured by tattooing. He travelled the world, returned to the UK and retired to village life before dying in 1969.

KRYSTYNE KOLORFUL
ONE OF THE MOST TATTOOED WOMEN IN THE WORLD

For 10 years, Canadian erotic dancer Krystyne has been on a quest to complete a full-on bodysuit. She has 95 per cent coverage, including a huge dragon spanning her chest and back. She shares the title of world's most tattooed woman with American Julia Gnuse, who adorned herself in tattoos to disguise the effects of rare skin disease porphyria. Despite showcasing a startling array of floral tattoos and gleefully shocking punters who come to watch her dance, Krystyne says she'll never let the needle go near her face. ➡

Krystyne says no to facial tatts

Tatt Fact
The prison tattoo of a dagger through a skull symbolises that the wearer is a killer

GENESIS P. ORRIDGE

THE ORIGINAL DEVIANT

Known for his sonic adventures with industrial bands Throbbing Gristle and Psychic TV, Genesis's self-experimentation in body mods was first documented in scene-defining book *Modern Primitives* (RE/Search, 1989). "We were exploring modern rituals and the idea of the human body being part of a canvas of art," he says. "At the time, it didn't strike us that tattoos and piercings would become fashionable." Manchester-born Genesis's most recent project, *Breaking Sex*, involved him having boob implants to help him merge identities with his (sadly recently deceased) wife Lady Jaye to create a new, androgynous being.

PICTURE: NEVILLE ELDER

36

TOM LEPPARD
LEOPARD MAN SPOTTED!

He claims to be uncomfortable in the company of people and lives on the Isle of Skye, UK, but ex-soldier Tom Leppard, or Leopard Man as he's known, does get to sink the odd pint on the mainland when he hops over for his pension every now and then. On the remote island, he washes in streams and climbs trees. After leaving the army, Tom forked out over £5,000 ($8,000) for his spot tattoos which cover 99.2 per cent of his body. He also had four of his teeth fashioned into fangs, and in 1987 made it into the record books as the most tattooed man – a record now lost to Lucky Diamond Rich.

Tom shows off the 'pouch crouch'

BETTY BROADBENT
A GALLERY OF A GIRL

Born in 1909, Betty Broadbent was a fresh-faced 17-year-old when she ran off with the circus. Betty asked renowned tattooists Charlie Wagner and Joe Van Hart to start on her bodysuit, and she worked with Ringling Brothers and Barnum and Bailey Circuses where she was billed as "the youngest tattooed woman in the world". She had over 350 tattoos, including portraits of famous American pilot Charles Lindbergh and Mexican revolutionary Pancho Villa. She travelled all over the world for 40 years before becoming a tattoo artist herself and then retiring completely in 1967. ⑬

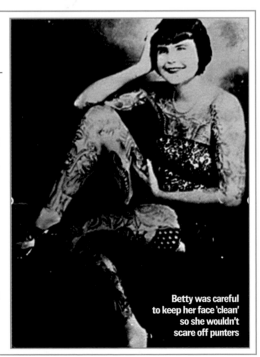

Betty was careful to keep her face 'clean' so she wouldn't scare off punters

MORE BODY MOD MARVELS

Get under the skin of more of the biggest names in body art – check out our exclusive interviews with decorative deities such as…

PAULY UNSTOPPABLE p56
He's only 23, but has every body modification under the sun!

ZOMBIE BOY p76
The man with his insides tattooed on the outside!

EAK THE GEEK p96
The guy who ran away from the circus to become a lawyer!

ISOBEL VARLEY p116
The most tattooed female pensioner in the world!

ELAYNE ANGEL p136
The first lady of extreme body modification!

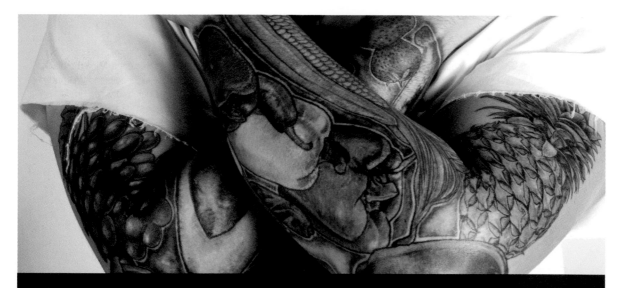

NATURE
INK INSPIRED BY ANIMALS, PLANTS AND THE NATURAL WORLD

MITCH BARRETT
Who did it? Paul Owen at Naughty Needles, Bolton, UK.
What is it? A mixture of stars and flowers, with some vines and swirls mixed in.
Why did you choose it? I love stars and thought mixing them with flowers would look pretty and feminine. I wanted a big tattoo, and this design looks good without being too much.

SHAILA DOWNEY
Who did it? Josh Cruse of Artist At Large Tattoo, Kansas, USA.
What is it? Scarab beetle in my right elbow pit.
Why did you choose it? I've always been fascinated by beetles of all types. Scarabs are definitely the toughest buggy guys out there.
What response do you get? It's great when someone says, "Hey, is that a scarab? Awesome!"

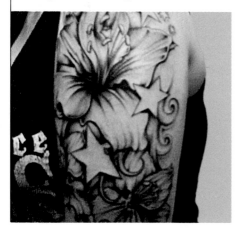

LEAH G.

Who did it? Tim from The Kernow Tattoo Centre, Camborne, UK.

What is it? Two snakes winding up and away from each other, with a Celtic knot in the middle.

Why did you choose it? I was born in the Chinese Year of the Snake, hence the serpents.

What response do you get? All good, except from my grandparents!

EMII E.

Who did it? A mobile tattooist in my area of Ceredigion, UK called Doz – top bloke!

What is it? Flowers, spider webs and black vines on the lower half of my back.

Why did you choose it? I drew it myself late one night when I finally decided I was going to get a decent back piece. I wanted something feminine, but with a twist.

TAMARA PLASKEWICZ

Who did it? Jef Wright, formerly of Magnum Tattoo, now at Love Tattoo, Michigan, USA.

What is it? My three dogs, Mina the black Labrador, Sol the silver-coloured Weimaraner, and Bucca the reddish coloured Vizsla.

Why did you choose it? My three dogs are my best friends and I wanted a way to keep them with me for the rest of my life. ➡

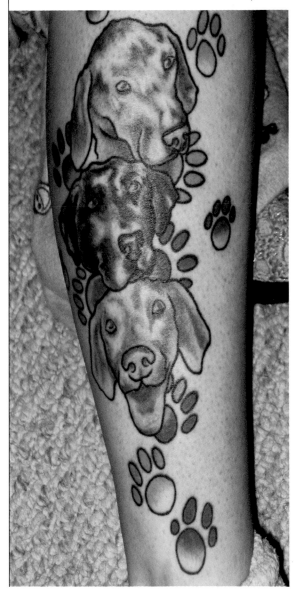

Your Tattoos

KATIE-MAY

Who did it? Mick at Blaze Tattoos, Canterbury, UK.

What is it? A clockwork stag beetle.

Why did you choose it? I saw an article about steampunk in Bizarre and came up with the design from there.

What response do you get? Even my granny says it's beautiful. It took three hours, and the neck bits really hurt, but I'd definitely do it again.

ANTONIA PRESTON

Who did it?
Dave the Buddha at Studio 81, Preston, UK.

What is it? Black roses on my upper left arm.

Why did you choose it? I wanted a beautiful design that I'd love forever.

What response do you get? People are constantly coming up to me in the street to say how nice it is, and find out where I got it done.

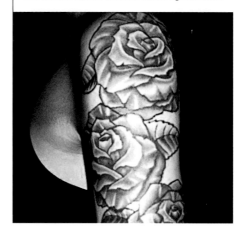

HEIDI PLAYER

Who did it? Greg at Big Daddy's Tattoo, Indiana, USA.

What is it? A ladybird on some flowers on the top of my foot.

Why did you choose it? I wanted a ladybird on my foot for luck, and I also love flowers.

What response do you get? People always comment whenever they see it.

TRICIA MARTIN

Who did it? Wiley from Dare Devil Tattoo, New York, USA.

Why did you choose it? Every Friday the 13th Dare Devil Tattoo create a bunch of new flash designs, each with the number 13 incorporated somewhere. On those special days their flash tatts are only $13, plus a $7 tip for the artist. So that's a $20 tattoo – well worth the trip!

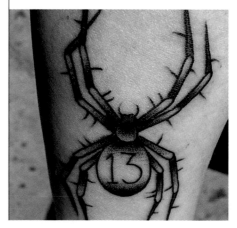

SARAH ANGELL

Who did it? Phil Kyle on *London Ink*.
What is it? A matching pair of magpies, with accompanying roses and banners.
Why did you choose it? It's a depiction of the traditional rhyme 'One for sorrow, two for joy'. It represents myself and my twin sister – aaw!
What response do you get? People love them and the colours. But my family hate tattoos!

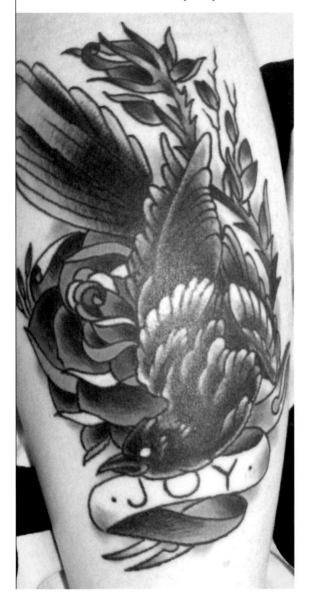

LATIFA

Who did it? Nick Bailey at Tribal Urge, Southsea, UK.
What is it? Butterflies over my right arm and shoulder blade.
Why did you choose it? I used to go to butterfly farms as a kid, and they symbolise me blossoming as a person. I also wanted my first piece to be big, which symbolises me wanting to run before I can walk!

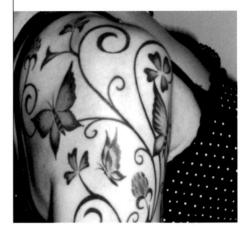

CS 'DALLAS' MCKENZIE

Who did it? Shane Munce, Philadelphia, USA.
What is it? Vegetable sleeves.
Why did you choose it? When I was younger all I wanted to be was rich, but after I collected everything I ever asked for I still wasn't happy. On a mountain in Colorado I had a moment of clarity and decided to become a chef. My sleeves remind me that my dreams are coming true. ⑬

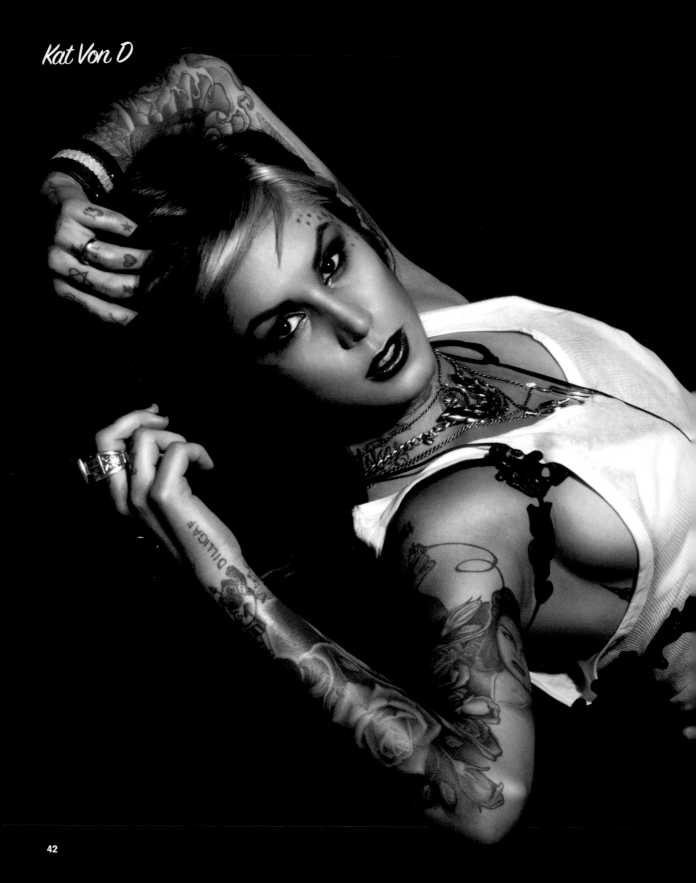

Kat Von D

Queen of Ink

KAT VON D, THE STAR OF *LA INK*, ON TATTS AND LOVE AND ROCK'N'ROLL… ➜

PHOTOS **LIONEL DELUY/CONTOUR BY GETTY IMAGES**
WORDS **CHRIS NIERATKO**

Kat Von D

needle at the age of 14 and etched a Misfits logo onto a friend's arm, Katherine Von Drachenberg has been crazy for the ink.

Kat started an apprenticeship in a parlour aged 16 and, after working in a string of tattoo shops, made a name for herself when she was picked as part of the crew in reality show *Miami Ink*. By the third season of the hugely successful series, Kat had left the programme to star in her own (even more successful) spin-off, *LA Ink*.

Nomadic by nature – with German, Spanish, Italian and Argentinian blood pumping through her veins – Kat's built a following thanks to her ability to identify with customers from every walk of life. She gets under the skin of her clients, but lets fans get under hers too. Her rock'n'roll personal life is laid bare in her TV series, as well as on her MySpace page. After her divorce in 2007, she started seeing Alex 'Orbi' Orbison from metal band Whitestarr – they've since split and she's now dating rock legend Nikki Sixx (the pair have matching tattoos). She's a terrifyingly talented tattooer, lives in Hollywood, is funny as hell and hangs out with rock stars. We gave the tatt-tease a grilling she'll never forget…

"I DID A MISFITS TATT ON A PUNK WHEN I WAS 14 – SINCE THEN I'VE BEEN HOOKED"

Hi Kat. How are you?
I'm a little sick. I have some kind of cold.

It's not the AIDS, is it?
Oh, no. I have the HIV but most of the time it's the cancer that makes me feel like this.

I only have one or two fluff questions, the rest will be fun. So let's get that out of the way. How did you get into tattooing?
I started tattooing when I was 14 years old. I started hanging out with a bunch of punk rock kids from around town, and one of the guys had a homemade set up and tattooed all of us. One day he said I should tattoo him. I did a Misfits tattoo on him and was hooked. I dropped out of school and started tattooing all my under-age friends. There was never a shortage of kids that wanted to get

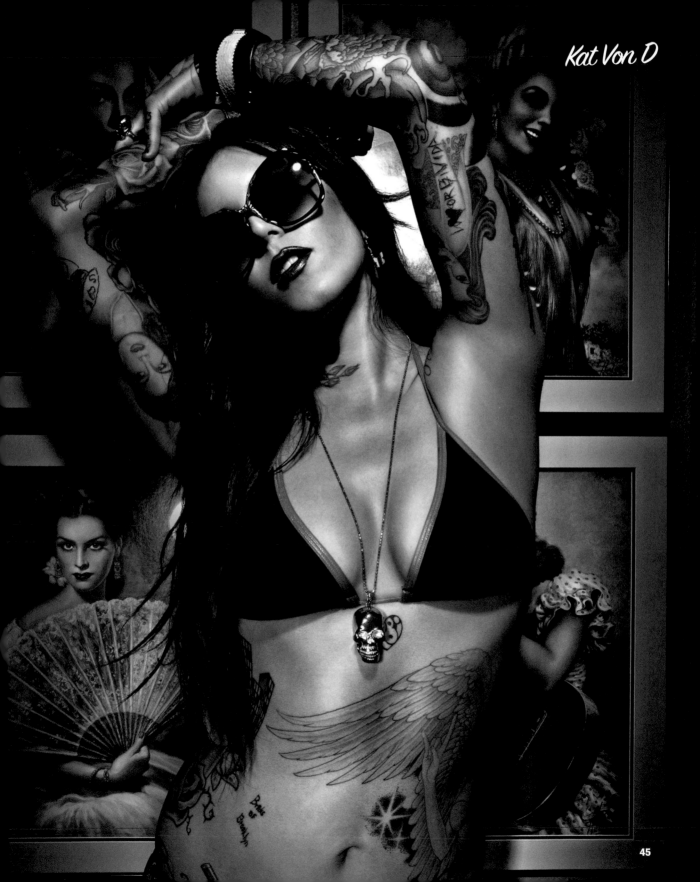

Kat Von D

Kat Von D

tattooed and didn't care that I sucked. By the time I was 16, I got a proper job in my first professional tattoo shop, where I had to unlearn most of the things I'd been doing for two years.

Do you think during those two years you gave anyone hepatitis?

No. Most 14-year-olds don't have hepatitis. It's hard to start an epidemic when no one's had sex yet or started using intravenous drugs.

Jackass's Bam Margera told me a story about you throwing glasses at Metal Skool (LA metal band that play The Viper Room).

God! I used to drink a lot of vodka at that time. I was married, was working out a lot, had lost lots of weight, and I'd be drinking full glasses of vodka. Bam always puts that in my face and it pisses me off – it's not like he hasn't pissed on the floor when he's slept at my house!

Did you ever imagine a photo of you in underwear would be plastered all over billboards?

"MOST DUDES DON'T THINK I'M HOT. THE TATTOO THING TURNS A LOT OF PEOPLE OFF"

That wasn't my underwear, silly – they were borrowed. But I don't think I'm a heart-throb. I thought the billboards (advertising *LA Ink*) worked. The majority of dudes out there don't think I'm hot. I think the tattoo thing actually turns a lot of people off.

Not true. Tattoos = dirty girl. I have a theory that 100 per cent of the time girls with tattoos...

Fuck better. Yes, that's true.

I was going to say like butt sex.

Oh really? Wow. That's way better than being a heart-throb. ➡

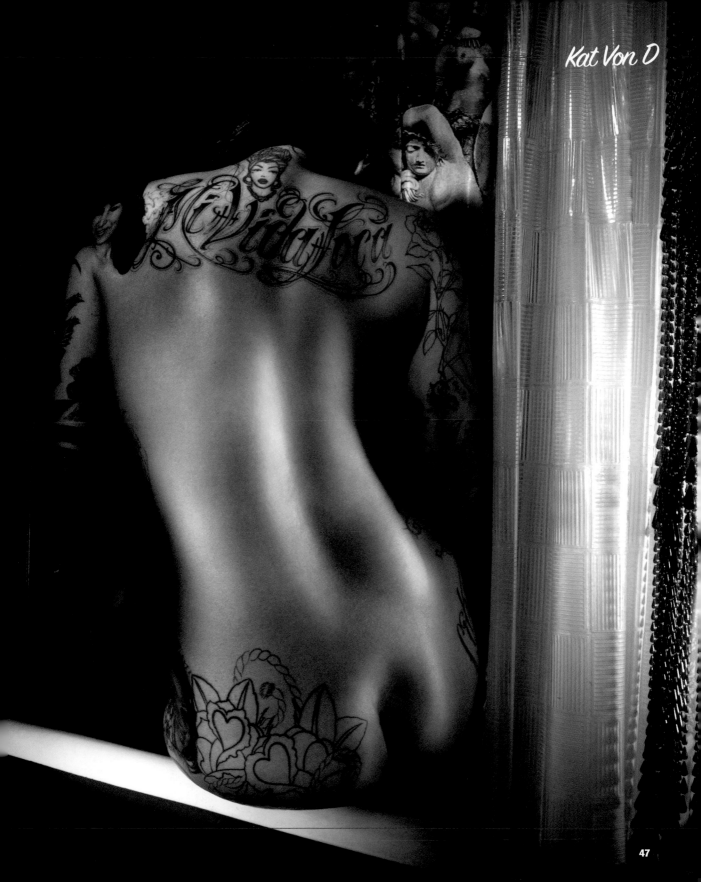

Oh man. I'd honestly answer that question if it wasn't going to bum out my publicist.

It doesn't require an answer because, as I said, 100 per cent of the time...

Uh-huh. I think you might be onto something there. It's something to wrap your mind around.

Do you think photos of you in your underwear are helping to turn a lot of young boys into men?

No, but I tattoo a lot of prison guards and they tell me I'm quite popular late at night in the jail cells. They watch LA Ink in prison. I get a lot of letters from jail. Like, "Hey, I have tattoos like you. We have a lot in common. Except I kill people." I love it. They usually say when they get out they're going to come and get tattooed by me. And a lot of them say Ami from *Miami Ink* is fucked up.

You and Ami had a major falling out. Are you still not speaking?

Yeah, that bridge is definitely burned. I haven't spoken

"MY FANS IN JAIL SAY WHEN THEY GET OUT THEY'LL COME AND GET TATTOOED BY ME"

to any of the *Miami Ink* guys since I left. Not even Garver. It's sad.

Does it make you cry?

No. But it was a heartbreak for sure – Garver was my homeboy at the time. But people prove themselves to not be down for you at times, and you just have to deal with that.

Do you ever do dances of joy on your bed when you get the ratings for your show back?

Ha. No, I don't jump around and dance. As long as the overall ratings say we're doing good, that's what's important. I'm definitely not driven by competition. I didn't get my own show to say, "Fuck you," to *Miami Ink*. Deep down inside I wish them all the best.

No you don't.

Yeah, I do! I don't necessarily want their show to do any better than my show, but I don't wish them any harm. But I do know that our show got triple the ratings that they ever got!

But you're not counting.

No. But the three months prior to the premiere I was super-depressed because I'd worked my ass off and then they didn't air the show right away. But it finally aired and my agent called, saying, "Kat, you're the most watched show for your time slot and you've got triple the amount of viewers *Miami Ink* ever had." And that wasn't so much a "fuck you" to Ami – it was more like all that depression was worth something.

And you made something good. *Miami Ink* was a ...

Monotonous and repetitive. The guys weren't willing to involve their real life in ➡

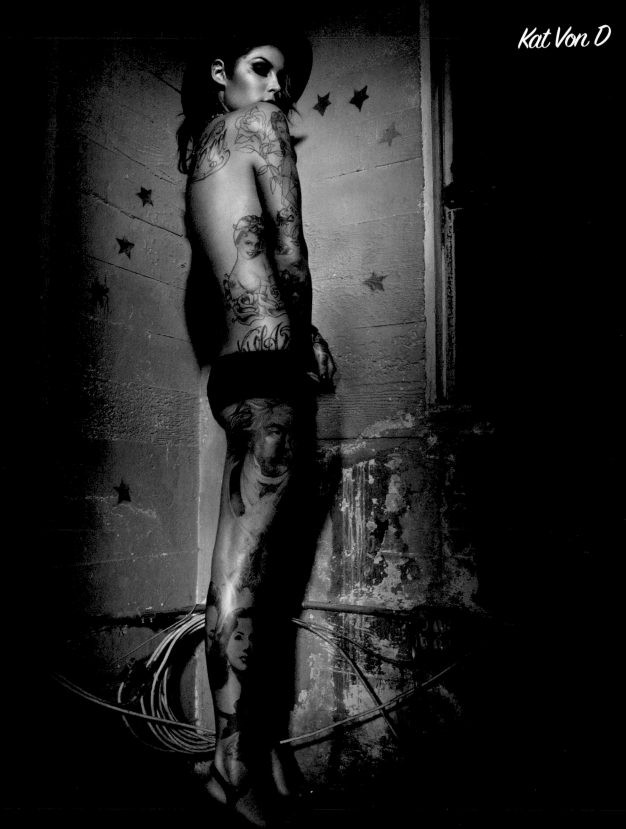

Kat Von D

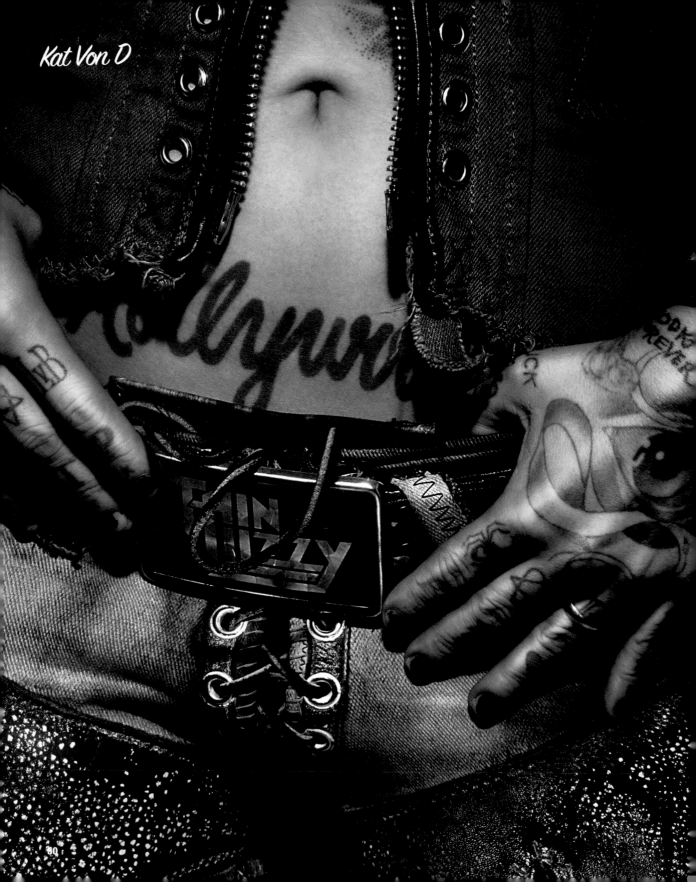

Kat Von D

the show, so everything was forced and produced. Whereas I promised myself that aside from my divorce, I'd talk about anything. People can relate to you more when you're real and open and show your imperfections. Our show is more rock'n'roll and fun and honest. I don't have any control over what's edited and there's definitely some footage out there where I'm wasted out of my mind, crying and really talking about gnarly shit. Thank God they didn't use it. But they could have.

What were the two weeks you spent at high school like?

Man, I hated it. I was hanging with all these older punk rock kids and the social aspect of it seemed lame. School was easy for me – I was always in the gifted classes. It was just the social part I hated. In junior high I'd always get in fights with people trying to talk shit, but I always knew there was something more important than being cool.

If you could be a tabloid editor, what sleazy Kat Von D story would you like to make up?

"SOME PEOPLE THINK I'M MAKING A MOCKERY OUT OF TATTOOING"

Let me think of a good one There'd be anal involved, I promise. Maybe we could say me and Amy Winehouse did it because we're both brunettes and have tattoos.

What's the worst thing about mainstream fame?

The worst part has been how much respect I've lost in the tattoo world. There are always going to be people that hate me and what I do. Some people in the tattoo industry think I'm making a mockery out of tattooing. All the hard work I've put in over the years went out of the window by me ➡

KAT'S TATTS

Kat's tells us the tales that lie behind her favourite ink…

STARS (FACE)
"I love the Motley Crüe song 'Starry Eyes'. I started off with one star on each temple and then, over the years, I added more."

KAT'S MUM (BACK)
"My Dad did lots of photography and he took this picture of my mother. I had to steal it from the house because she wouldn't give it up!"

MI VIDA LOCA (BACK)
"It's Spanish for 'My Crazy Life'. It's a gangster thing. I just like the meaning behind it and how it's inspired tattooing in Latin culture."

KAT'S DAD (INNER WRIST)
"This tattoo was from a photo of my dad in the 60s. He's my hero and best friend. I travel a lot, so it's nice to be able to just look down and see him."

THE INITIALS 'DILLIGAF' (HAND)
It stands for 'Do I look Like I Give A Fuck?' I started tattooing it on all my friends' right handslike a crew".

'LOGAN' (ARM)
"Tom Green did this for me when I went on his show. Logan was the name of the camera guy on the show, and Tom would keep yelling his name."

TWO PIN-UP GIRLS (RIGHT ARM)

"Pin-up girls are having a definite comeback at the moment. You can't go wrong with a pretty girl!"

ANGEL (TORSO)

"I call it my angel of death, and it's also the name of a Slayer song. My whole life is about LA, so I wanted to get a cool rocker angel."

'HOLLYWOOD' (STOMACH)

"Hollywood's a place where people come from all over the world to find opportunity. And the weather's great."

BEETHOVEN PORTRAITS (ONE ON EACH LEG)

"I'm a classically trained pianist. Beethoven was a romantic and had this constant battle inside his brain. He's my dream guy."

YEARBOOK (LEFT LEG)

"My yearbook leg is like a piece of history for me. Friends who can't even tattoo have inked me! I had a lot done at parties when I was drunk."

INITIAL (ANKLE)

"This was my first tattoo, the initial of my first boyfriend. I have fond memories of those three years we spent together."

being on TV. I knew the network wanted a girl for the show, and if I didn't do it they'd use some hot girl who'd been tattooing for three years to represent everything I'd worked for since I was 14. But I've had a real backlash.

What are you driven by?

I'm not driven by status or money because I was successful prior to the show. My family are my number one priority, and I've been supporting them for a long time.

Does the backlash bother you?

It hurts to be discredited because I love tattooing. It's an art form saturated with

"TATTOOING IS FULL OF PEOPLE GETTING INTO IT FOR THE WRONG REASONS"

people who are getting into it for all the wrong reasons. One thing I'm proud of with the show is how weirdly educational it's turned out to be. My parents never set foot in my shop until the show came out. My dad called and said, "Kathy, I didn't know this is what you do. You help people." That was awesome. Every person can relate to the stories being told on the show and that's a great thing.

Anything else you want to get off your chest?

You know what really creeps me out? Every time I go to do a meet and greet there's always a gypsy fortune teller there. And they always say, "There's lots of death around you and something bad's going to happen." I look at them and say, "If you were really fucking psychic you'd know I didn't want to hear that." I mean, what a buzzkill.

Gypsies are jerks.

Totally. My mom was a gypsy. They scam people. She'd tell me how she'd "read people's palms". It's all bullshit. Ⓑ

Check out more of Kat at Katvond.net or Highvoltagetattoo.com

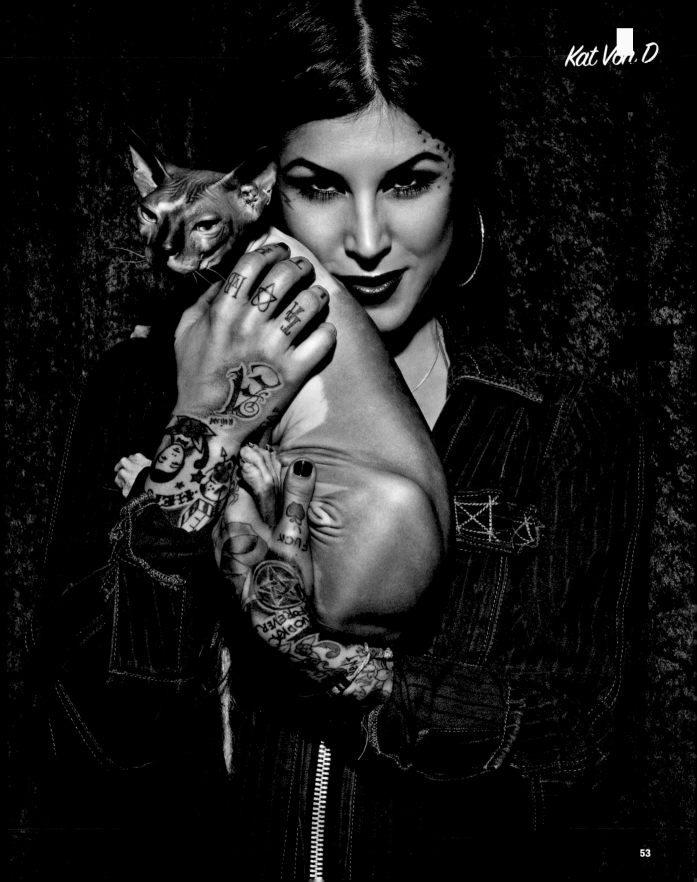

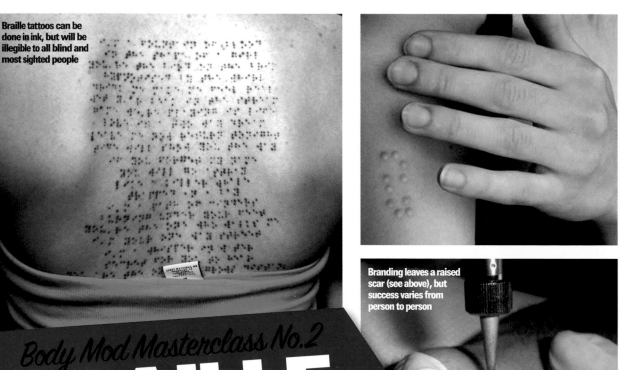

Braille tattoos can be done in ink, but will be illegible to all blind and most sighted people

Branding leaves a raised scar (see above), but success varies from person to person

Body Mod Masterclass No.2

BRAILLE TATTOOS

IMPORTANT!

DON'T TRY THIS AT HOME

IT'S DANGEROUS! IF YOU WANT TO MODIFY YOUR BODY IN ANY WAY, SPEAK TO A PRO

THINK BLIND PEOPLE DON'T DIG TATTOOS? THINK AGAIN. THE VISUALLY IMPAIRED CAN ALSO ENJOY YOUR INK

Just as people come in all shapes and sizes, so do tattoos. And while the art form of body inking is traditionally thought of as purely visual, there are some tatts that can be enjoyed by the blind and visually impaired. In fact, Braille tattoos are an effective way to communicate with a section of the community often ignored by alternative culture.

There are two approaches to Braille tattoos. If you want a tattoo that any sighted person who understands Braille can read, a normal ink tattoo will be fine. However, a blind person won't be able to read it. While it might sound strange to have an inked Braille tattoo only sighted people can read, is it any different to English speakers who get kanji (Chinese characters) tattoos? In both kanji and Braille, the wearer appreciates the shape of the letters visually and the meaning separately. If you

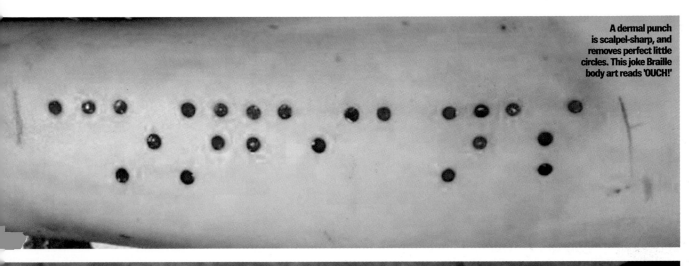

Can any readers translate this last example? Let us know…

have a tattoo in a language you don't understand, it's easy to disconnect the aesthetics of the letters from the actual meaning.

If you want a Braille tatt the blind or visually impaired can read, texture is key. While you could use a tattoo machine without ink to create scars – a method known as 'etching' – there are better ways of getting a functional Braille tatt: branding is one, skin removal is another.

Branding leaves a raised scar, but can heal unevenly and success varies from person to person. That's why you should consider skin removal – a dermal punch is like a cookie cutter for the skin, and removes perfect circles of flesh. It's normally used for doing biopsies, and will yield the most even dots for a functional Braille tatt.

Subdermal implants also create functional Braille

BOTH SIGHTED AND BLIND PEOPLE CAN READ BRAILLE BODY ART

tattoos. There's potential for implants to slightly shift position under the skin, but if you use a solid piece of Teflon or harder silicone – or even a piece of metal with bumps on – you could create a much finer Braille design. They can even be positioned in a fleshy area of the body so it doesn't raise the skin, isn't visible to the naked eye, and can only be felt if you press on your flesh. Oddly, that would be the total opposite of a conceptual Braille tattoo as you wouldn't be able to see it at all – but you would be able to touch, feel and read it. Ⓑ

PICTURES: BMEZINE.COM, NADIA PRIGODA

MEET THE MAN WHO PIERCED HIS SCROTUM, SPLIT HIS PENIS, AND TATTOOED HIS OWN FACE

PHOTOS **NEVILLE ELDER**

PAULY UNSTOPPA

ince the first *Body Art* book came out, Pauly Unstoppable has become a poster boy for extreme body modification.

A resident of the small city of Whiteland, Indianapolis, USA, Pauly has taken body modding to unprecedented new heights, his collection of flesh art including implants, brandings, scarification, tattoos (including one on his eyeball), piercings, nullification (see p134), a split tongue and more. He even became a minor celebrity when his stretched nostrils broke out from body mod website BMEzine.com onto message boards across the internet.

Though Pauly's only a tender 23, body modification has been a part of his life for as long as he can remember. We caught up with him to get under the skin of his modding obsession…

Where do you think your obsession with modifying your body comes from?

My family is supposedly descended from Maoris, so that could be where my cravings stem from. I had my ears pierced when I was seven, and when I was about 10 I started putting larger stuff in my ears to stretch the holes. Around that time I also pierced my septum (the piece of cartilage separating the nostrils) with a sewing machine needle – obviously not the best method. The only people who saw my pierced septum before I was 18 were the kids at school – normally, I'd just flip the jewellery inside my nose when I didn't want anyone to see it.

Although your body is hugely modified, it's arguably your nose that made you famous…

Sure. When I stretched the piercings in my nostrils to 38mm and put pictures online, a lot of people reacted to them. I had a huge piece of nostril jewellery in the middle of my face! Most people would ask me how I did it, how long it took and, of course, how did I sneeze?

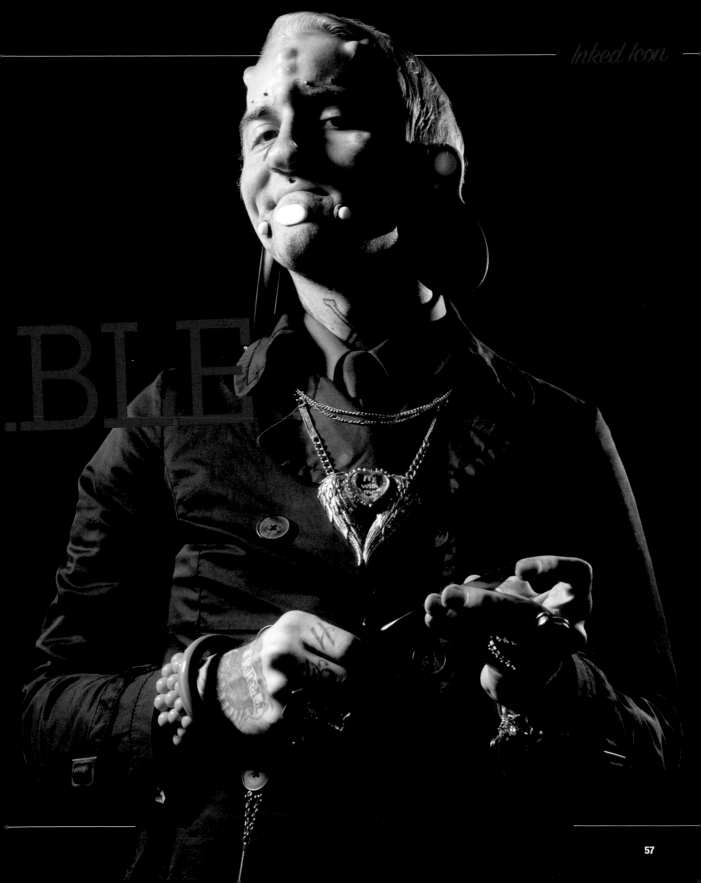

.BLE

It's unusual to see such large nostril piercings. What inspired you to do this?

I saw a guy called Pat Tidwell who'd stretched his nostrils to over half an inch, and I was curious to see how far mine would go. I didn't want to outdo people or get the world record or anything like that. When I got to 38mm, I figured that was a plateau. I could've got even larger, but it was becoming uncomfortable to wear on a daily basis. If I have a mod that becomes uncomfortable, I won't keep it. You can't live a normal life if you're in constant pain.

Are there health implications in stretching your nostrils so wide?

Opening my nasal passages and breaking down

"WHEN I WAS 15, I SPLIT THE BOTTOM HALF OF THE HEAD OF MY PENIS"

the barriers so that bacteria and dust can get in is something people are concerned about, but it hasn't affected me at all. I never get sick. And when I blow my nose, all I do is cover my entire nose.

You started out pretty young…

Yeah, around the same time as I was stretching my ears, I pierced my scrotum and nipples and performed a Prince Albert penis modification on myself. When I was 15 I did my meatonomy, which is the splitting of the bottom half of the head of the penis. I cut from my urethral opening to where my Prince Albert was. I just opened the head up and from there cut another 63mm. I did it with a razor blade, which isn't advisable, but that was all I had – along with my determination to do it.

Jesus! Wasn't that dangerous?

Definitely, and I wouldn't recommend DIY procedures. But speaking personally, I wouldn't change a thing and I don't regret anything I've done. I cringe a little when I think about the unsterilised razor blade I used to cut open my own genitals. But kids will be kids, eh?

Do kids ask you for advice on DIY modding?

Yeah, kids often message me and ask, "How should I do this?" or "How should I do that?" But I always say,

<div style="writing-mode: vertical">PICTURES: BMEZINE.COM</div>

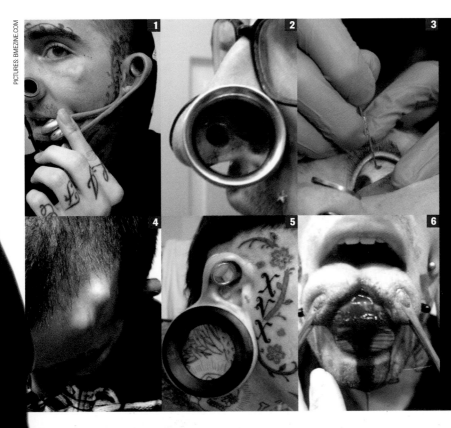

PAULY'S MODS
THE BOY'S DONE GOOD…

1 **Ears stretched to 95mm**
2 **Upper nose cartilage stretched to 25mm**
3 **Eyeball tattoo**
4 **Horn implants**
5 **Pierced conches**
6 **Tongue split**

NOT TO MENTION…

Nostrils stretched to 38mm; lip stretched to 30mm; star implant in his temple; heart implant in one eye; genital, face and body tattoos; sub-incision (genital splitting); large scrotal piercing; genital rib implants; partial nipple removal; branding on chest and scarification on thighs.

"No sugar, m'aam – I'm sweet enough!"

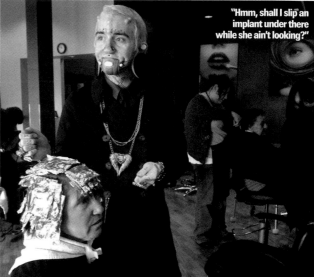

"Hmm, shall I slip an implant under there while she ain't looking?"

"WITHOUT MODS, I FELT LIKE AN ALIEN IN A WORLD OF HUMANS"

"You shouldn't." It's better to get them done professionally – or else you can seriously injure yourself. If you're trying to split your own tongue, or remove your nipples or something in the bathroom at home, you can hit a vein and cause severe blood loss. If you hit a wrong nerve trying to do a genital mod you can lose sensitivity. Body modding is dangerous if you're not trained.

When you first appeared on the internet, a lot of people claimed your extreme modding was the result of a "sick, sick" childhood…

It was like a recurring thing on messageboards – that my parents must not have loved me, that I was going to work for the rest of my life in McDonald's… All those people were hiding behind their screens and had nothing better to do with their time. I have an awesome relationship with my mother. I had a normal childhood. I wasn't molested or anything.

Tatt Fact

After the first Gulf War, Saddam Hussein punished deserters by having 'X' tattooed on their faces

Perhaps your most drastic modifications are the Teflon ribs you implanted under the skin of your penis, creating a ribbed condom effect.

I also have stars tattooed on the top of my penis, as well as a sub-incision – an opening in the urethral canal. It helps to stimulate more nerve bundles in that area. That's why some people enjoy putting things down their urethra.

Do you ever worry that the way you look will stop you from living a normal life?

I didn't ever want to get stuck in a monotonous job. If that happened, it would cause me to hate my life. So I genuinely don't have any regrets.

Alright, now tell us about the name…

The name Unstoppable came about because I have a habit of attracting, but overcoming, bad luck. Stuff's happened to me that you shouldn't be able to bounce back from.

Tell us more…

I was hit by a drunk driver and ended up in a coma. A few years later I tried to commit suicide and overdosed. I've been shot and stabbed. I've been set alight. And I've fallen out of a third storey window. I seem to attract a lot of crazy things, but they always end up OK in the end.

Have you finished modifying your body now?

I want to go further. When I didn't have mods, I felt like an alien in a world of humans. Through adorning myself, I'm making myself more human. Some people say, "You've wrecked your life, you've wrecked your face." But I tell them that it's my mind, my body, my time and my money. And I'm going to do whatever the hell I want with it. Ⓑ

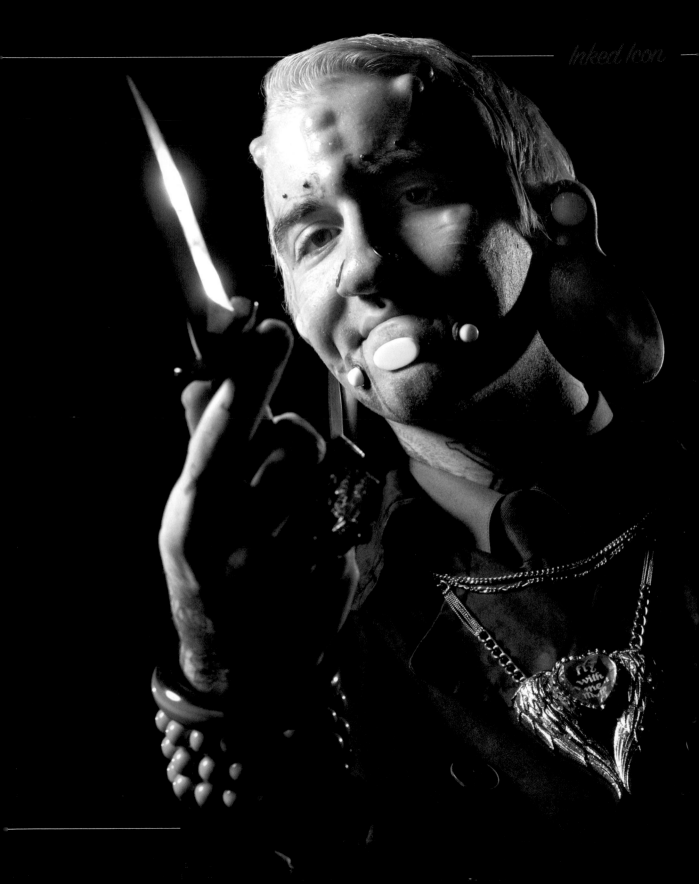

SKULLS

LIKE IN THE FIRST *BODY ART*, SKULLS ARE A POPULAR CHOICE

ALLISON JAMES

Who did it? Freak at Miss Heidi's Tattoo, Orlando, USA.

What is it? A skull on top of my head.

What response do you get? Wide eyes and lots of questions from everyone!

What other ink do you have planned? I plan to put roses along the side, but I won't change the skull. The more ink I can have, the better.

LEANNA SEELEY

Who did it? All my work has been done by Mark Watson at Terrapin Tattoos, Luton, UK.

What is it? Skulls on my toes.

Why did you choose it? I have many skulls tattooed on my body as I have a fetish for pirates – I even have a skull tattooed just above my pussy! I also have a treasure map inked on my hand.

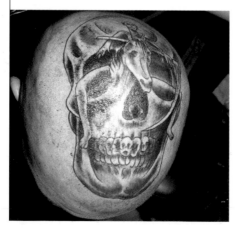

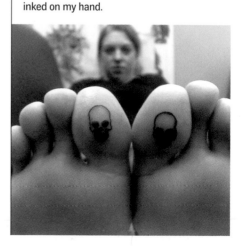

RACHELLE HERNANDEZ

Who did it? My brother in law, Rick Hernandez.
What is it? An old school skull, with the number 13 on its forehead, surrounded by flames.
What response do you get? People love it.
What do your family think? They love it too – my family is very tattoo-friendly.
What other ink do you have planned? I plan on getting two nautical stars on my arm.

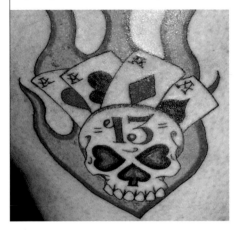

LISA PURNELL

Who did it? Paul Slifer at Red Hot And Blue Tattoo, Edinburgh, UK.
What is it? A bright and busy little party.
Why did you choose it? I'd never planned to get a full back piece, but it grew over the years. I love Paul's work – he just grabs every idea and turns it into something beautiful and fun. My tatts raise smiles mostly, but also the odd frown! ➡

PAUL WILLIAMS

Who did it?
Julian Hiscock at Skin Scene, Jersey, UK.
What is it? An HR Giger themed cyber skull – it took over a year to do.
How do you feel about it now? I still love all my tattoos. I think they're dark and interesting, and I don't give a toss what people think about the fact I have skulls all over me!

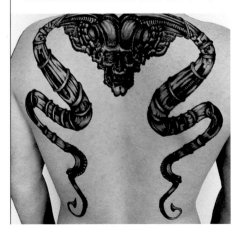

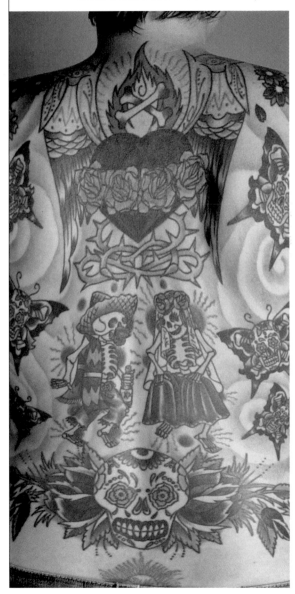

Your Tattoos

MATTHEW PERRY

Who did it? Kevin at Tattoo You, South Shields, UK.
What is it? It's the logo for Joker Brand clothing.
Why did you choose it? Just because I liked the design and it's a bit different.
What response do you get? Most people love it – they think it's an unusual tattoo.
What other ink do you have planned? I want a sleeve on my left arm and tribal art on my leg.

KITTY ROMANEK

Who did it?
Raoul at Shit For Life, Munich, Germany.
What is it? Skulls and flowers.
Why did you choose it? I got my inspiration from studying medicine. I liked the metaphor of life coming from death, and vice versa.
What response do you get? As it's on my chest, people tend to stare at my tits more!

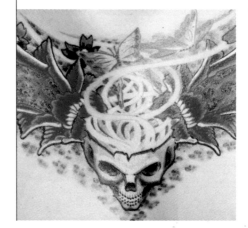

DEMANDA LAVETTE

Who did it? Chris Howell at Liberty Tattoo, Atlanta, USA.
What is it? A lady skull with roses, holding a Sacred Heart and rosary beads.
Why did you choose it? I wanted a skull, but I wanted her to be girlie. I'm Catholic, so I wanted religious imagery in there too.
What response do you get? People love it!

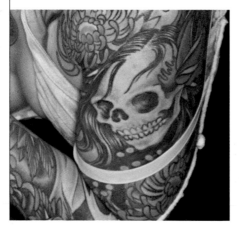

PAUL WHILE

Who did it? Emily at World of Tattoos, Ruislip Manor, UK.
What is it? HR Giger's Li II design.
Why did you choose it? I'm a big fan of Giger's work – the attention to detail using airbrushing is unmatched compared to similar artists. I've always wanted to display his work on my body – its unique, dark and beautiful.

TORRIE BIELBY

What is it? It started as just the skull, flames, cards and my sister's name, then later I added the heart and wing, the swallow and my son's name, with clouds and stars as a colourful background.

What response do you get? People are surprised how big it is, especially when I lift my trousers up. They don't expect such a big tattoo!

KAREN CANN

Who did it?
Phil York at Tattoo Mania, Gateshead, UK.
What is it? Jack Skellington on my fingers.
What response do you get?
Lots of positive comments.
What other ink do you have planned? I'm having work on my chest to begin joining the tattoos on my upper body into one flowing piece.

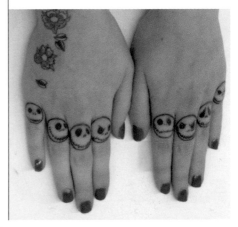

BRANWYN REEVES

Who did it? Nearly Painless James at Epic Tattoo, Woodstock, USA.
Why did you choose it? This represents my tenth anniversary of being off speed. The ravens symbolise wisdom and courage. The 'nevermore' is pretty obvious – no more speed for me! – and the two skulls remind me of the two times I overdosed and was declared clinically dead. Ⓑ

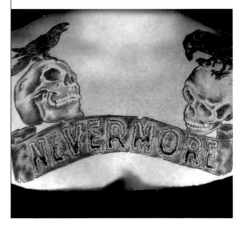

GOB STOPPERS

FROM FEARSOME FANGS TO ELECTRIC BRACES, *BIZARRE*'S ALIX FOX CHECKS OUT MOUTH MODS TO MAKE YOUR JAW HIT THE FLOOR

WORDS **ALIX FOX** PHOTOS **JOE PLIMMER**

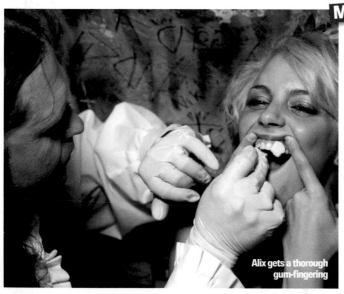

Alix gets a thorough gum-fingering

MOUTH MOD No.1

FANGS

VAMPIRE FANGS FOR WANNABE BLOODSUCKERS

I wanted to know what it would feel like to have a bespoke set of fangs made to fit my own toothy pegs, so I arranged to meet special effects maestro Robbie Drake at London's Soho goth bar Garlic & Shots to do just that.

Sitting at a wax and vodka splashed table made from a genuine coffin, Robbie certainly looks the part in his lace collar and floor-sweeping leather coat. He smiles to reveal a fearsome pair of 20mm fangs. With 20 years' experience creating special effects, his company, Blood Red FX, have worked on a wide variety of cult flicks including Clive Barker's *Nightbreed*. The insiders' choice for incisors, Robbie has also helped groups such as UK fang fans The Vampyre Connexion supersize their spikes. But what would he make of my pearly whites?

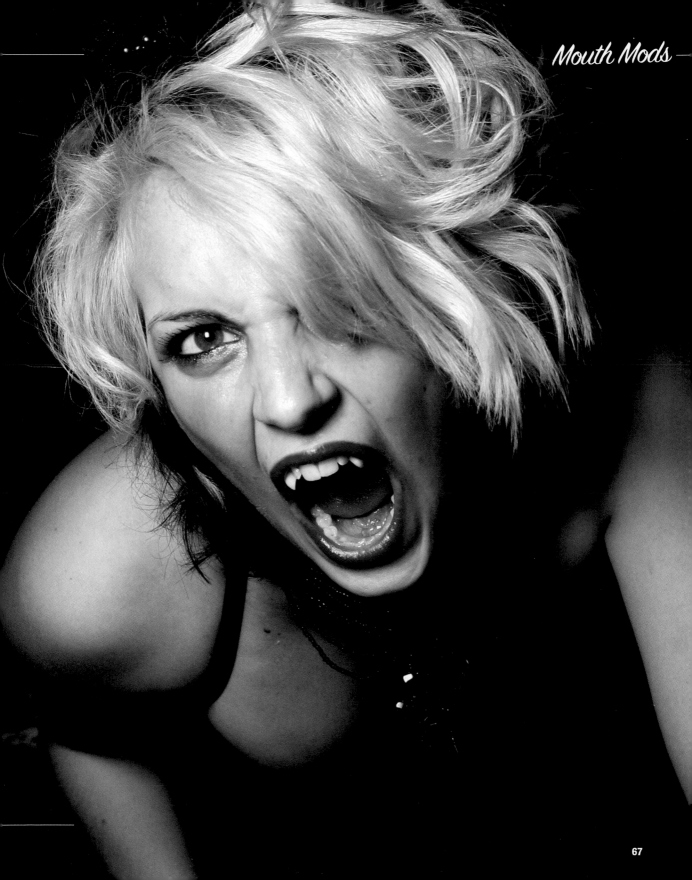

First up, Robbie tells me my teeth aren't so white after all. Fangs are made by mixing a cocktail of chemicals that come in a range of 'vita shades' – spanning from zero to four – to match the colour of your teeth. Bright gnashers are a zero; my red wine-stained efforts are about a three.

When preparing my new teeth, Robbie stirs the liquids in a small tub under a heat lamp; in a few seconds he has a ball of creamy putty the consistency of sticky putty.

I open my gob as far as I can, and Robbie moulds a hazelnut-sized ball of goo over each of my canines. For the next five minutes, I elegantly hold my lips away from my gums while the putty sets. The reaction produces heat, and I can feel my teeth and tongue getting toasty. It's not painful, but there's a weird fizzing sensation. I can't help but drool, and I've soon created a pool of saliva in my lap.

Once the setting time is up, Robbie has to yank the moulds off – and I wonder if my teeth are about to come out at the root. "The materials can adhere quite solidly, but the suction always eases up eventually," he says. "There's no way the mould could get permanently stuck."

Next, Robbie uses a sander to transform the now-hard globules containing imprints of my canines into rough fang shapes. Clouds of white powder fly everywhere.

"When *Buffy* mania was at its peak, I got a lot of requests for vampire fangs," Robbie muses, using a fine file to refine the tooth points. "Now people are after the classic shapes seen in *The Lost Boys* and *Blade*. And I do a good trade in small, subtle fangs for committed vamps to wear during the day. An average pair costs about £100" ($160).

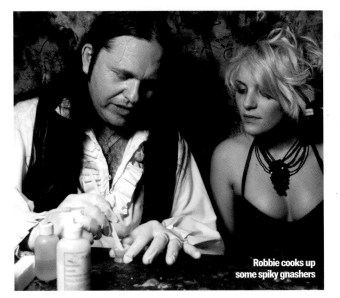

Robbie cooks up
some spiky gnashers

THE FAKE FANGS ARE SHARP ENOUGH TO DRAW BLOOD FROM MY FINGER

Robbie slips the creations in and out of my mouth to check they match, making tiny adjustments with the sander by eye. Finally, the fangs are buffed and polished and it's time to play dead.

My new nibblers make me feel sexy as hell, and are sharp enough to draw blood. Unfortunately, they also make me sound like Count Duckula. "You'll quickly get used to them and be able to talk normally," says Robbie. "Don't sleep in them, as teeth-grinding can damage the points and your tooth enamel. And don't keep them in while you eat, just in case you swallow them."

What does Robbie reckon to permanent fangs? "I've heard of dentists who implant porcelain fangs or cement on spiked veneers," he says. "But that's a terrible idea. The human jaw isn't shaped to hold carnivore-style teeth for long periods, and you can wreck your bone structure."

I'll be sure to take my fake fangs out at night as instructed, then, and keep them in a contact-lens case to remember which one is left and right. Until necks time…

Get a fangstastic fix at Bloodredfx.com

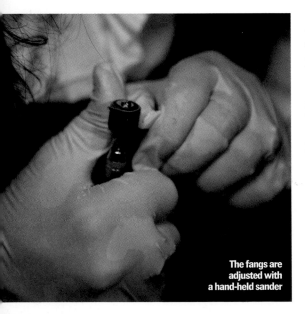

The fangs are
adjusted with
a hand-held sander

Tatt Fact
Traditionally, an un-tattooed Samoan man couldn't marry or speak to his elders, and could only perform menial work

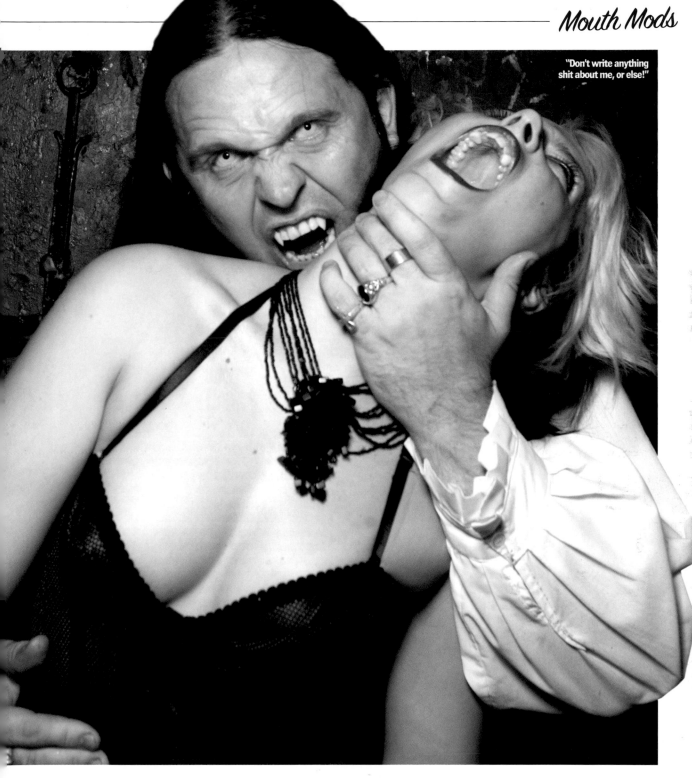

"Don't write anything shit about me, or else!"

MOUTH MOD No.2

BRACES

**FAKE BRACES FOR DECORATION...
AND MOUTH FETISHISTS**

Beautyandbraces.com is a niche fetish site for folk who don't care whether a lady spits or swallows – as long as she does it with a mouthful of train tracks. A collaboration between kink photographer Michael Andrews (check out Privateplanetnetwork.com) and braces enthusiast Mario B, the site is an essential stop for anyone interested in modifying their mouth, or understanding the impact a gob of metal can have on others.

If you fancy trying a metal make-out session of your own, but your teeth don't need a proper brace, fake mouthpieces are available from the USA and Japan (a Google search will reveal dozens of vendors). They were originally developed to allow kids blessed with straight smiles to fit in with their snaggletoothed friends, but they've now been embraced as erotica. We quizzed metal lover Mario B on how he became a tin man...

Mario, you like a girl's cakehole to showcase more metal than a VH1 Megadeth special. Why is that?
In the desensitised world we now live in, people need more than just a naked body to turn them on. Mouth

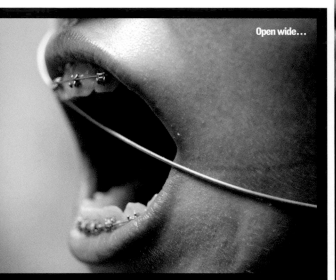

Open wide...

PEOPLE HAVE BRACES WIRED TO BATTERIES FOR ELECTRICAL FUN

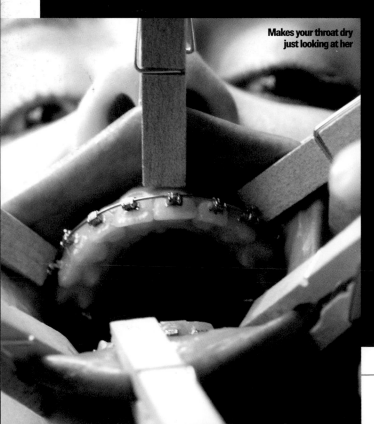

Makes your throat dry
just looking at her

braces are like piercings, nylons and high heels – they're an erotic accessory that adds an extra, enticing 'je ne sais quoi' to eroticism. Braces have links to the bondage scene, and take things to a new level of intensity for those already intrigued by mouths in general.

And what do your iron maidens get up to?
Our members crave girls with their mouths open wide, so we often stretch their lips apart with 'fishhooks' or vintage headgear. We photograph models biting down on fruit and licking sweet liquids, brushing and flossing, or sometimes girl-on-girl, tin-on-tin kissing. Braces can be customised with coloured inserts and elastic bands, and in one shoot our mistress Vanisha ran an electrical current through a retainer. We also have a mouthpiece hotwired to a battery pack that vibrates in the person's mouth.

If a girl in braces goes down on you, don't you risk getting your genitals ripped?
When you're new to wearing braces, things can take a little adjusting to. But I can assure you that most brace-based, oral sex horror stories are just urban legends designed to scare horny teenagers!

Grillz: No friend
of candy apples

MOUTH MOD No.3
GRILLZ
ALIX FOX PIMPS HER TEETH!

Grillz are entire sets of teeth crafted from gold or platinum and encrusted with diamonds, emeralds and the like, which temporarily fix over your ratty mouth furniture to give your smile a blinged dazzle.

Popularised as part of the USA's hip-hop scene, they're now creeping into UK fetish clubs. British site Grillzncastings.co.uk even sells them alongside a corpse facial-casting service to "preserve the features of a loved one who's passed away".

True grillz fit teeth in a similar way to bespoke fangs and, if you go for expensive metals and precious stones, can cost thousands of pounds. However, the pink and silver 'girls' grillz' I tried out

(see above) come decorated with cubic zirconia, and are £16 ($25) a set from Theblingking.co.uk. It's worth remembering that, as with any jewellery made from cheaper metal, you run a higher risk of having an allergic reaction.

I fix on the sparkly suckers by melting a supplied wax strip in warm water until it's clear, which is then sandwiched between the grillz and my gnashers for two minutes. I check they're in place, and hop on the train to see how the public will react. My mouth packed with metal, it takes several spit-flecked attempts to tell the conductor where I want to go, and my pimpin' look clearly isn't imposing enough to swing a free ticket. Several commuters ask if I'm off to a James Bond convention as Jaws. I feel utterly silly. The only grillz I'll be shopping for in future are of the lean, mean, fat-busting-machine kind.

Tatt Fact
Around 220 BC, tattoo artists in south-east Asia added opium to pigments to alleviate their subjects' pain

PICTURE: ANGELL

71

Tatt Fact

Kat Von D holds the world record for the most tattoos inked in 24 hours, after tattooing 400 people with the *LA Ink* logo in December 2007

Do. Not. Fucking. Move

MOUTH MOD No.4

TONGUE TATTOOS

WHY NOT INK YOUR LICKER?

Mac and Rob from Punctured Body Piercing in Devon, UK are masters of mouth mods – in particular, tongue tattoos.

At the moment, only basic designs such as numbers or symbols are possible, although a guy in LA claims he's created inks that taste of garlic, chocolate and vanilla. However, Mac and Rob reckon that's "ludicrous".

Although tongue tatts tend to heal quickly into raised marks, they also fade fast as acids in the mouth will eventually dissolve the tattoo pigment. Then again, you might be glad your tatt's gone if you end up with a blob in your gob because you couldn't keep still. "We can't use a clamp while inking as it'd distort the surface of the tongue," Mac says. "We have to grip it with a bit of tissue, and tell clients not to move a muscle." Gulp. MySpace.com/puncturedbodypiercing

A whole licka lurve

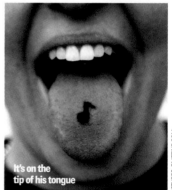

It's on the tip of his tongue

PICTURES: BMEZINE.COM

YOU NEED TO KEEP DEAD STILL WHEN GETTING YOUR TONGUE TATTOOED

MOUTH MOD No.5

HOME INCISOR PIERCING

DON'T TRY THIS AT HOME, KIDS!

Home incisor-piercing – where a hole is drilled into your tooth and a piece of jewellery poked through it – is one tooth-or-dare we're happy to pussy out of. But some internet fruitcake claims to have drilled a hole through his tooth with an electric drill and hung jewellery from it.

So, is this mod for real? *Ripley's Believe It Or Not!* regular and body mod king Lizardman (see p33) says his highly-skilled dentist got through a lot of professional drill tips when performing his tooth-filing. So we find it hard to believe you'd be able to get suitable materials from a hardware store to achieve a neatly pierced result.

However, Lizardman also told us that tribal cultures have been filing their teeth with simple materials for yonks, and that the process isn't as painful as you'd think – so perhaps it *is* possible to make your own little tooth tunnel without chipping your gnashers, cracking the enamel, slipping and drilling a hole into your brain, or breaking the sound barrier with your screams. Thanks, but no thanks.

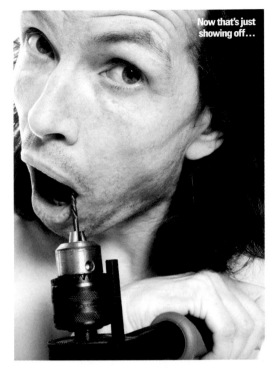
Now that's just showing off…

MOUTH MOD No.6

TOOTH TATTOOS

GRIN AND BARE IT

Tooth tattoos have been doing the rounds for a while in the USA, where you can have an iccle piccy etched onto a crown or veneer, which is then cemented onto your gnasher. The process is designed to be permanent, although the tatts can be ground off if you tire of using your grin as a gallery.

Also available in India and Germany are temporary dyes, painted on teeth by dentists, and day-long, rub-on designs. The latter, called Tat-2s, are currently marketed to kids to encourage them to brush their teeth properly; once the stuck-on heart, lightning bolt or spider has shifted, so has the sugar. We bagged a pack from eBay and gave 'em a whirl; they tend to wrinkle a tad as you apply them, and wear away after a few glasses of plonk, but having a smile full of smiley acid faces was still fun for clubbing. Ⓑ

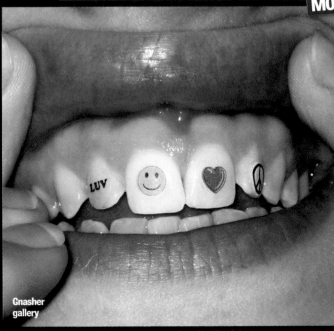
Gnasher gallery

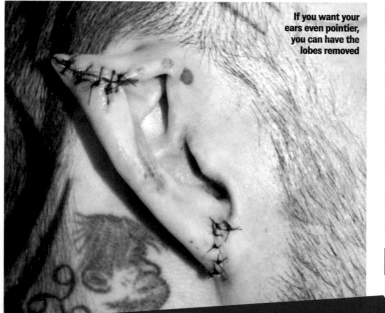

If you want your ears even pointier, you can have the lobes removed

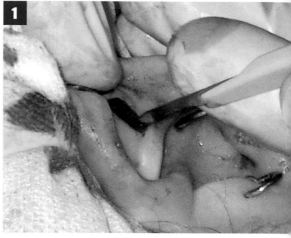

Body Mod Masterclass No.3
EAR POINTING

IMPORTANT!

DON'T TRY THIS AT HOME

IT'S DANGEROUS! IF YOU WANT TO MODIFY YOUR BODY IN ANY WAY, SPEAK TO A PRO

EVERYBODY'S GOING ELFISH – HOW TO GET YOUR LUGS SNIPPED

Ear pointing is more common than you think. In fact, after ear piercing it's probably the most common type of ear modification. It's certainly more accepted than procedures such as ear shaping, cropping and ear lobe removal, although the latter may sometimes be done in conjunction with pointing to achieve an extreme effect.

The first ear pointing procedures took place in the mid-1990s, but it's taken off in the past five years thanks to the work of body artists such as Lukas Zpira, Jonathan Martinez, Matias Tafel and Brian Decker.

Some ear modders prefer to have a downward-facing point, almost like a troll or an orc. We don't think that's due to the popularity of the *Lord of The Ring* movies, though – it probably has more to do with the fact that once it's in the media, more people start doing it.

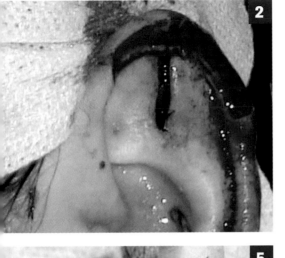

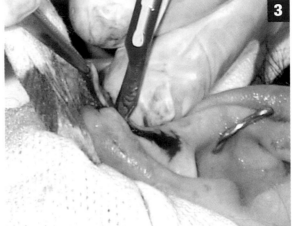

HOW YOU GET POINTED EARS

1 An incision is made into the ear cartilage

2 A small amount of cartilage is removed

3 The top of the ear is folded

4 Stitches are used to hold it in position

5 The ear heals into the folded shape

6 Don't forget to have both ears done...

Body modfather Steve Haworth performed the first ear pointings in the mid-1990s, and is credited with inventing the procedure. Haworth developed the idea for sideshow performer Katzen The Tiger Lady, and based the technique on a procedure in which animals have their ears docked.

The most common way of performing an ear pointing is to remove a small amount of cartilage from the ear, fold it, and then suture the fold in place. The ear then heals in this folded position. However, Samppa Von Cyborg used a different method to fold and trim the helix (rim) of the ear to create a point. This involved restructuring the ear after skinning it, elevating the thin skin of the conch (the ear's outer rim), trimming the exposed cartilage using surgical scissors and a scalpel (while leaving the helix intact), then removing the excess skin before stitching the skin back together as neatly as possible. This is a painstakingly slow

EAR POINTING IS A PRETTY LOW-RISK AND COMMON PROCEDURE

and incredibly delicate procedure, but results in pointed ears that look more natural.

Ear pointing is a pretty low-risk procedure. There may be some change to your hearing, but it's so minor you probably wouldn't notice. However, consider ear pointing a non-reversible procedure. An experienced surgeon might be able to repair it if you change your mind, but there's no point in messing around with flaps of skin that'll be on the side of your head for the rest of your life. ⑬

PICTURES: BMEZINE.COM

ZOMBIE BOY

MEET RICK – THE BOY WHO'S PERMANENTLY COVERING HIS OUTSIDE WITH HIS INSIDES

WORDS JACK RUBY MURRAY PHOTOS NEVILLE ELDER

 ick is turning himself into a zombie. So far, more than 24 hours of tattoos – costing more than £4,000 ($6,300) – have got him halfway there and made him a minor celebrity on the internet, where surfers can't decide if he's a body modification visionary or mentally ill sicko. We caught up with Rick in his hometown of Montreal, Canada, to see what life is like when you're transforming yourself into the living dead…

What are you trying to achieve with your tattoos?
They're about the human body as a decomposing corpse – the art of a rotting cadaver.

What influenced your tattoos?
When I was a kid I was a big fan of the Teenage Mutant Ninja Turtles, and I wanted to be a ninja warrior and live in the sewers. But as I got older I fell in love with zombies and wanted to become one. Oh, and I love George A Romero's *Living Dead* movies. Anyway, the closest thing I could get to becoming a zombie was to get tattooed like one. I see my tattoos as celebrating the art of obscenity and the macabre.

When did you decide you wanted to get tattooed?
I thought long and hard about what I wanted, and what my passion was. And I decided I wanted to be a fucking zombie! My first move was getting my hands outlined with a skeleton print.

How do you feel about your tattoos now?
They've been a part of me forever – before I even got them done. They reveal how I feel on the inside. I'm so used to how I look now that I don't see them any more. It's like if you met someone with purple hair – after 10 minutes you'd ➜

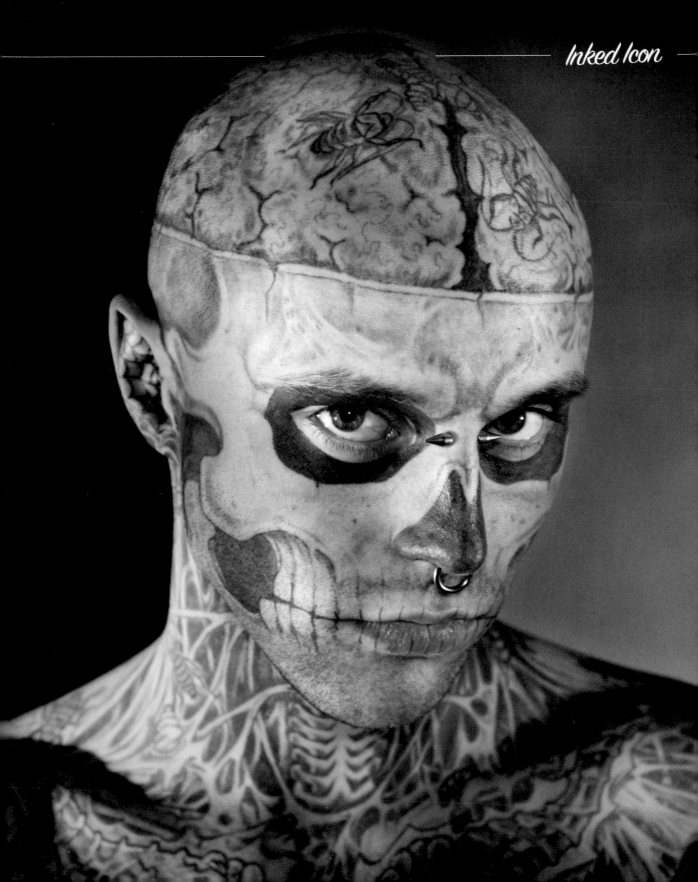

think, "Oh yeah, they have purple hair. So what?" But it does look a little different to how I'd imagined. I expected some portions of my tattoos to look more bloody and gory. Probably because I've got an overactive imagination and I'll never be satisfied with the results.

What would you do differently?
I'd have a lot more blood in general, dripping and oozing everywhere. I'd love to have blood pouring out of my eyes and a few more bugs here and there.

What do your friends think?
My friends think it's cool. It's punk rock.

How about your mum?
Well, I don't think this is what my mother had in mind for me. When I got my hands done it broke her heart. But once she saw I was determined about it she was like, "If that's what you want to do, make sure you go all the way. Don't just start it and then change your mind. If you're going to be sure enough to tattoo your fucking face like that, then you've got to be sure enough to follow through with the whole fucking thing."

Tatt Fact
Californian prison tattoos often incorporate the number 187 – the state's criminal code for homicide

Don't worry, ol' timer, it's not a 'Nam flashback – it's just Zombie Boy!

So she's behind you now?
Yeah. At first, when it didn't have the shading or anything, she was like, "You look like crap. You're going to be a punk your whole life." But now it's taking shape and become more like an art piece, she gets it.

How do people react to your tattoos?
There's all sorts of weird shit going on in Montreal, so I kind of blend in. Sometimes you get a smart-ass kid who yells, "Hey, it's Halloween!" Just about every day I get a skeleton joke. The classic is "Why didn't the skeleton cross the road? Because he didn't have the guts."

Do you worry about how you're going to look when you're older?
No, fuck it. Everybody ages. Are you worried about what you're going to look like when you're 60? It's

"I WANT TO GET MY EYES TATTOOED BLACK, SO IT LOOKS LIKE I HAVE HOLES IN MY FACE"

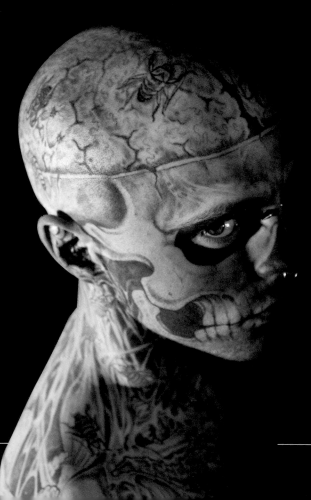

just life – tattoos turn green. I joke that once my body suit's done, the tattoos will be so faded that I'll have to start at the beginning again.

What other body modifications are you planning?
I want to get my brain shaded in all nice and grey, like hamburger meat. And then I want to get Frankenstein bolts sticking out of my head, around the rim where my scalp's 'cut off'. And in five years from now, if no one's gone blind from it by then, I'll go and get my eyes tattooed completely black, ➡

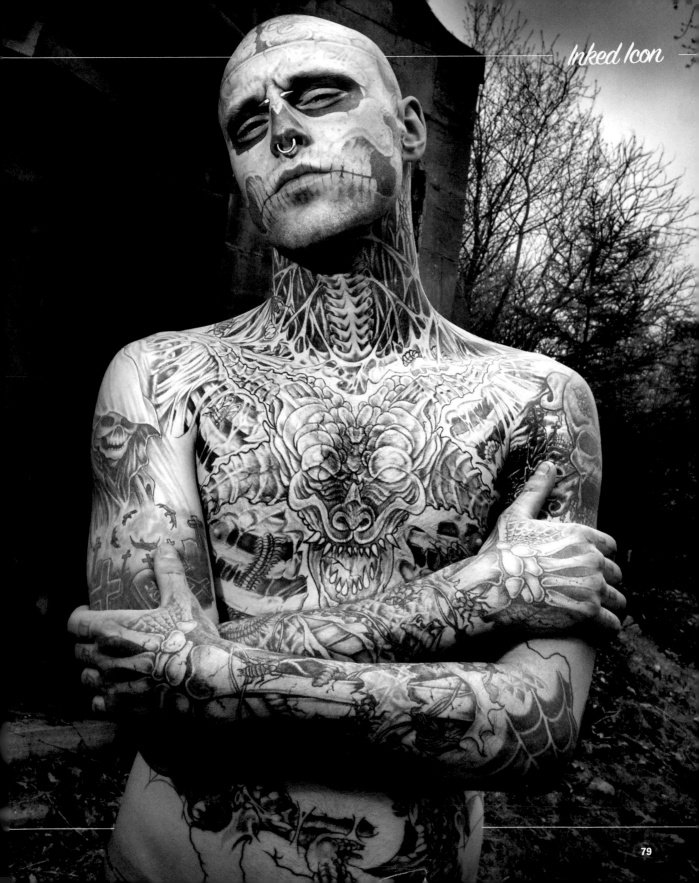

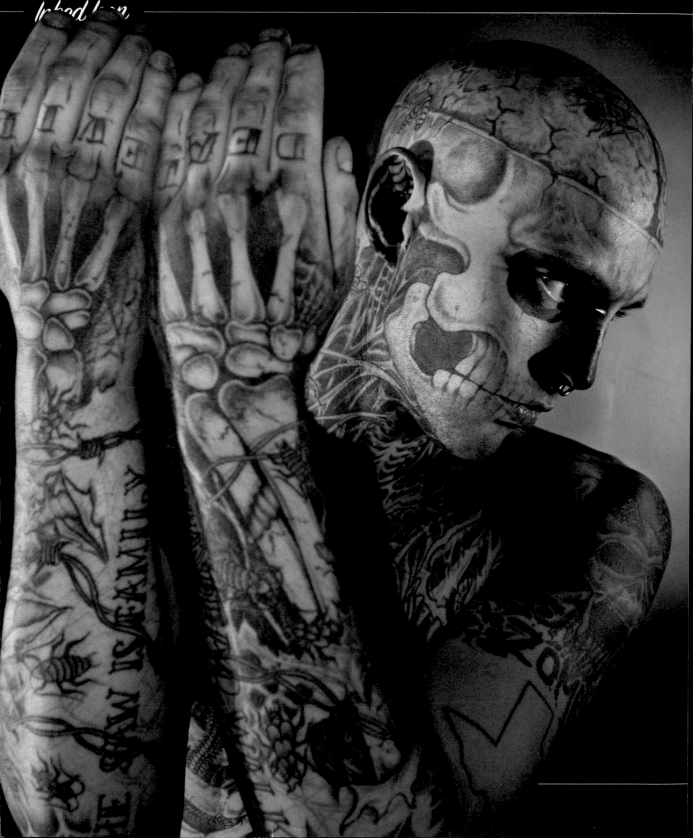

so there are big holes in my face. As for tattoos, I've still got to get under my arms done, then I've got to finish the intestines and the demon on my chest. I'm going to get bones sticking out of my knees, my toes done in skeleton print, and have patches of muscle scattered around, with worms coming out of the wounds.

Have you ever thought about having the tip of your nose removed?
Yes, and I've seen it on TV. This guy had a flesh-eating disease and was able to get his nose cut off because they gave him a prosthetic replacement. I was so jealous.

Would you have your ears removed?
Maybe just the one. I was thinking of having worms coming out of one ear and a spider's web in the other. But if I met someone who could remove my ear and get the right result, that would be cool as hell. If I saw someone walking around like that I'd shit myself.

Would you burn yourself with acid to get texture on your skin?
I don't know. I'm not a pro. But it has nothing to do with pain. I like pushing the limits to see how much I can take. I'd get my tongue split, I'd get my teeth sharpened. I wouldn't cut off one of my fingers, because I want to play guitar. But there are no rules about how zombies look. My buddy has a tattoo where his throat's slit and bugs are coming out, with worms up the side. It looks fucking awesome.

What advice do you have for people who want the same kind of tattoos as you?
They're fucking stupid and should get their own idea. You've got to be original. I hate copycats. But I'm up for the idea of more living dead people wandering

"That's so awesome! If you tweak his nipple he smiles!"

"I'M THINKING OF GETTING REPTILE SCALES AND ROACHES TATTOOED ON MY COCK"

around. I think a whole crew of people who had their faces tattooed as skulls would be awesome. But you can't just go and rip off someone else's look. And I don't want kids to go out there and ruin their lives just because they think I look cool – it's got to already be in you. You've got to know what you want. I mean, I've sacrificed my whole future for this.

What effect has it had on your love life?
Well, there are girls who dig how I look, but unfortunately the kind of girls who dig it

are usually looking for trouble.

Some people might look at you and think you're mentally ill...
They might do, but I'm not. I'm very on the ball. I'm realistic, sane and intelligent.

Is there any kind of body modification you wouldn't have?
Cock-splitting. I've seen pictures of that and it's not for me. But I'd tattoo my cock. I'm thinking of having reptile scales and cockroaches. I thought about having my cock tattooed like a Cyclops Jesus ding-dong. There'd be a crown of thorns around it, an eyeball and some scales. And there'd be a crucifix in the background, so my cock would be like Jesus on the cross.

Do you think your life would be better or worse if you hadn't had your tattoos done?
Actually, since having them done I've become a much happier and nicer person. Before, I hated pretty much everything and everybody. I just wanted to pass out in the gutter and swear at cars as they went by. That's why I got the skull tattooed on my face in the first place, I suppose – I wanted to fucking kill everybody. But now I've been having so much fun with it that life's definitely changed for the better. I honestly wouldn't change a thing... not that I have much choice in the matter.

How do you sum up your philosophy to life?
I can't tell you what to do and you can't tell me what to do – but if we respect each other's choices, we can still get along just great. Ⓑ

Tatt Fact
A survey of tattooed women by the Archives Of Dermatology found 40 per cent had received negative comments about their ink

GIRLS
PRETTY GIRLS INKED ON YOUR PRETTY FLESH

CARRI NATARELLI
Who did it? Bob at Bob Tyrrell's Night Gallery, Detroit, USA.
What is it? A Living Dead Doll.
Why did you choose it? I had an appointment with Bob, but because it was my first tattoo I was having a hard time committing to one image. But as my Living Dead Doll is my most prized possession, that's what I decided to get.

CHARLIE ROBERTSON
Who did it? Lynda in Gothenburg, Sweden.
What is it? A pin-up lady with tattoos.
Why did you choose it? Because pin-up girls are just too sexy!
What response do you get? People say, "Wow! That's the best tattoo I've ever seen in Brighton!"
What other ink do you have planned? I'm going to add more pin-ups!

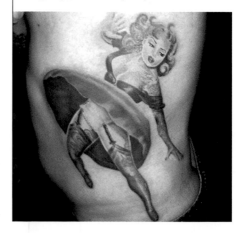

CLAIRE STUART

What is it? A smoking hot jester girl.
Why did you choose it? Because I've always loved the imagery associated with carnivals and the circus, and I adore the pin-up style.
What response do you get? Generally positive, but I'm frequently asked why she's nude.
What other ink do you have planned? An Alice's Adventures In Wonderland sleeve.

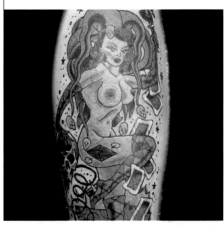

LADY ZOMBIE

What is it? The tattoo depicts a fierce-looking demon embracing a voluptuous woman (who's chained at the wrists) from behind. Her clothing is shredded, her body is nude and vulnerable, parts of her flesh are scratched and cut from his claws, yet she's still emitting a sexual vibe.
Why did you choose it? It symbolises how I'm bound to my true, darker urges.

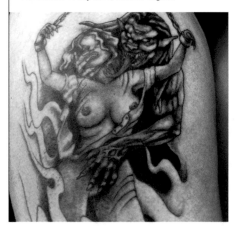

HOLLIE BRYANT

Who did it? Dawnii at Modern Body Art, Birmingham, UK.
What is it? A Hawaiian pin-up girl.
Why did you choose it? I love vintage Hawaiian pin-up posters of the 1940s, and I wanted to recreate them in a tattoo.
What response do you get? A lot of people stop me and ask who did it, and if it hurt. ➡

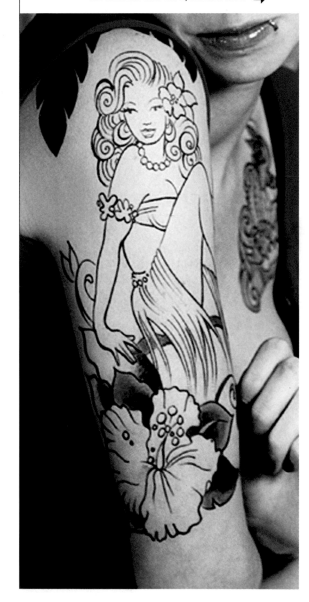

Your Tattoos

NICOLA ATHERTON

Who did it?
Chris Hatton at Physical Graffiti, Cardiff, UK.
What is it? A pin-up girl on my forearm.
Why did you choose it? I wanted a Hawaiian theme and a unique piece that represents me and the things I like.
What response do you get? A lot of people seem to like her. Even my dad is OK with it.

SARAH DANNEMAN

Who did it? Kele Idol at Aerochild Tattoos, Alabama, USA.
What is it? A female version of The Crow.
Why did you choose it?
I got the tattoo to remember actor Brandon Lee when he died. He's my hero.
What response do you get? People think my tattoo is badass – and they wonder if it hurt.

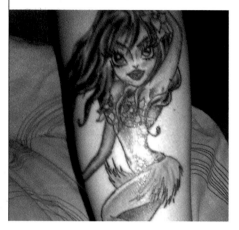

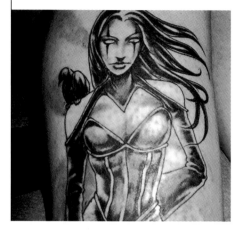

THOMAS WHELAN

Who did it? Jim at Colorfast Studios, Coral Springs, USA.
What is it? A vampire girl by Spanish artist and illustrator Victoria Frances.
Why did you choose it? Because I have an affinity for vampires.
What response do you get? People love it, especially the detail and the shadowing.

EMMA ROSTRON **Who did it?** Tiny Miss Becca at Thou Art, Sheffield, UK.
What is it? Mermaid half sleeve.
Why did you choose it? I grew up by the coast and always had a connection with the sea, and I used to go searching for mermaids as a kid. I was convinced that I was a mermaid – but because I'm a bad swimmer, I thought they'd taken away my tail as well as my swimming skills.

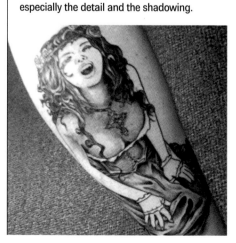

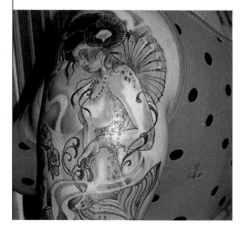

TOM HAYCOCK

Who did it? Geoff at Blue Fire, Chingford Mount, UK.
What is it? A devil girl.
Why did you choose it? I went to Geoff with the intention of getting a Coop-style pop art devil girl after seeing an article in *Bizarre*. Geoff showed me this picture as an alternative to the pop art look, and I loved it. I'll be going back to get another one on my left calf soon.

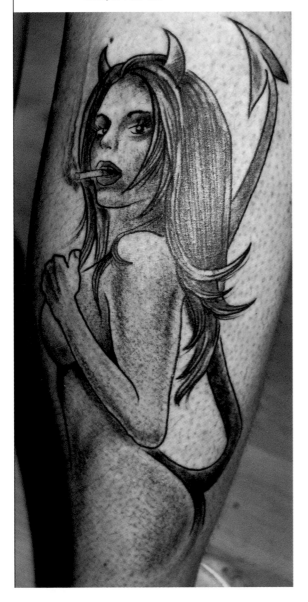

SHAI

Who did it? Robert Hall (Uncle Bob) of Uncle Bob's Tattoo Studio, Clarksville, USA.
What is it? It's an angel that covers a quarter of my body, all done freehand. So far, 16 hours of work have gone into her. The angel is the angelic Belladonna (one of *Bizarre*'s favourite porn stars).
Why did you choose it? I wanted something dark but yet light, and came up with this piece.

LUKI GODDI

Who did it? Jeff Ortega at Evil From The Needle, London, UK.
What is it? An anchor and two mermaids.
Why did you choose it? I've always loved mermaids since I saw *The Little Mermaid* when I was a kid. I got a crap tribal tattoo when I was 15, and needed to get that covered – and now there's no trace of it left. **⑬**

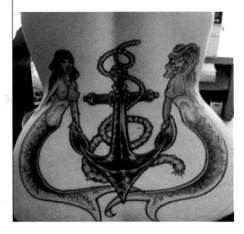

Tattoo
World Tour

WHEREVER YOU GO IN THE WORLD, YOU'LL FIND A LEGION OF ARTISTS ACHING TO INK YOUR FLESH. HERE ARE A FEW OF OUR FAVOURITES...

WORDS **DENISE STANBOROUGH, KATE HODGES**
MAIN PHOTO **JOHN STONE/JONCOJP.COM**

HORIHIRO

LOCATION
NUMAZU, JAPAN
WEBSITE HORIHIRO.COM/ENG

How did you start?
My mother was a geisha, so I saw men with full bodysuits come into our house as a child. I built my first tattoo machine from transistor radio parts and, aged 13, began working on friends.
Who's your typical customer?
Most of my clients are Yakuza (Japanese mafia). They're good

clients, but if customers from rival gangs have appointments at the same time it's a problem. Often a client who's a week away from having their bodysuit completed will get caught and go to jail for six or seven years. That really sucks.
Ever had a tattoo disaster?
Because I tattoo gangsters, if I made a mistake it could be a huge problem. So I can't afford to make errors!
What advice would you give to an aspiring tattooist?
Do it because you enjoy it, not for the money. If you truly love it, clients will come to you naturally. ➡

COLIN DALE

LOCATION
COPENHAGEN, DENMARK
WEBSITE TATTOO.DK

What do you specialise in?
I do a lot of historical and neo-Nordic designs – things like stick men with giant phalluses – which originate from the Scandinavian Copper Age 5,000 years ago.

Ever had a tattoo disaster?
When I started Eskimo sewing it didn't look too good. You coat a reindeer tendon in soot, and stitch it through the skin using a bone needle. When it's pulled out it leaves a line.

What advice would you give budding tattooists?
Don't grab onto a symbol that doesn't mean anything to you.

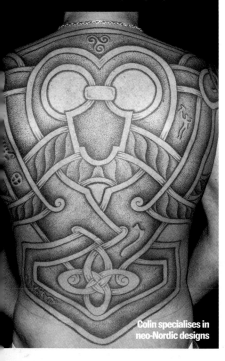

Colin specialises in neo-Nordic designs

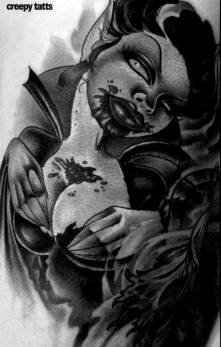

One of Joe's creepy tatts

JOE CAPOBIANCO

LOCATION
CONNECTICUT, USA
WEBSITE JOECAPOBIANCO.COM

What's your speciality?
I'm mainly known for pin-up work. Nine times out of 10 I'm asked to draw a tattoo where boobs are the main focus.

What's the weirdest thing anyone has asked you to tattoo?
Nothing freaks me out. I've been asked to do all sorts, from a schoolgirl being seduced by a Mother Superior to a devil girl going down on a female angel.

What advice would you offer to anyone getting a tattoo?
Research your artist – you have to search to find the best one for you.

HORIMYO

LOCATION
SAITAMA, JAPAN
WEBSITE 13PROJECT.COM

What do you specialise in?
I do tebori, where needles are manually inserted by hand. There are few tebori artists left in Japan – most people use machines now.

How did you start tattooing?
It took four years of wanting to do it before I took the plunge. Most Japanese tattoos are in a Yakuza style, and to be an artist often meant becoming a gangster, which I'm not. I don't have any Yakuza clients.

Who's your typical client?
Company directors, workers and truckers – all by word of mouth – which creates an intimate atmosphere.

This man may be a gangster. Or he might have respiratory problems

MARCUS KUHN

LOCATION
PORTLAND, USA
WEBSITE MARCUSKUHN.COM

How did you start tattooing?
I got involved in the punk scene in Mexico City. Back then there were only homemade machines in Mexico, so I built my own.

What's your work like?
I'm really classic – girls, pirates, pirate girls, skulls. Everyone asks me for Day Of The Dead skulls – even though I never did these back in Mexico. I use a lot of black and grey because in Mexico people's skin is darker, so it's difficult to use colour. I prefer crude jail styles, where the meaning is more important than the technique. ➡

YANN

🇨🇦 **LOCATION**
QUEBEC, CANADA
WEBSITE YOURMEATISMINE.COM

When did you start tattooing?
While I was an illustration student. I bought a machine to tattoo my friends.

Is there anything you won't do?
If a customer is self-assured and wants to have their hands or face tattooed, I won't object. But I make them aware that they risk excluding themselves from society.

Who's your typical customer?
Usually people who wouldn't be interested in having a tattoo until they see my work. And people who need cover-ups.

MAX TATTOO

LOCATION
BANGKOK, THAILAND
WEBSITE
MAXTATTOOBANGKOK.COM

How did you get into tattooing?
I got a traditional dragon tattoo in Singapore when I was 15 and I was hooked. I started my own shop in 2002, and I now have seven tattooists working there.

What style of tattoo do you do?
Oriental designs and freehand work.

Who are your typical clients?
We get a lot of Swedish and English tourists. We also get celebrities from Taiwan, Thailand and Hong Kong.

Any advice for budding tattooists?
Draw lots – it's an important part of your art. And trust your imagination.

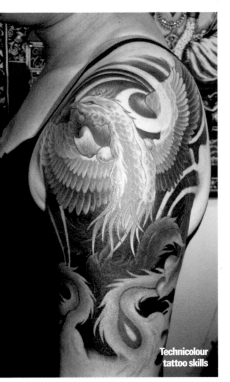

Technicolour tattoo skills

ALEX BINNIE

LOCATION
INTO YOU, LONDON, UK
WEBSITE ALEXBINNIE.COM

What do you specialise in?
Tribal and a sort of tribal fusion.

Is anything taboo?
Facial tattooing, though it's getting more common – it puts you outside society's norms. Hands are fine. We do swastikas, but not Nazi ones.

Who's your typical customer?
Someone in their 30s, university educated, and with a well-paid job.

What's the oddest job you've had?
We worked on Lucky Diamond Rich, the most tattooed man in the world. We did loads of inking – and then he had his whole body blacked in, mainly at our shop. ➡

PICTURE: ASHLEY/SAVAGESKIN.CO.UK

Alex Binnie: Tribal expert

TIM KERN

LOCATION
NEW YORK, USA
WEBSITE MYSPACE.COM/ YMONSTER

Is there anything you won't tattoo?
Stuff that goes against my personal ethics, like racist stuff. If someone asks for tatts on their hands I'll try and talk them out of it. It makes them instantly unemployable.

What do you like inking?
Horror images, realism, things that seem kind of ridiculous but look good when you tattoo them.

What advice would you offer to anyone getting a tattoo?
You'll spend hours with your tattooist, so make sure you like them

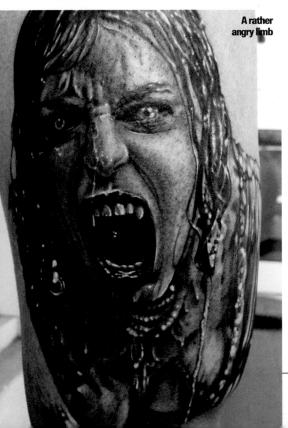

A rather angry limb

HORIYASU

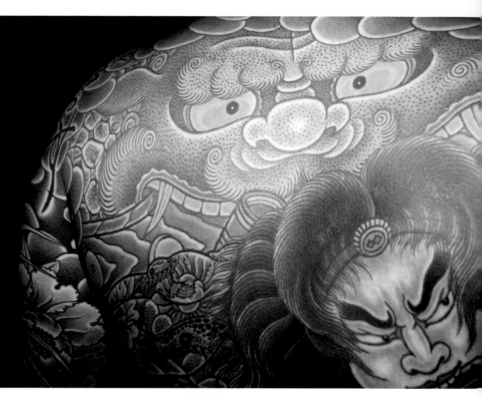

LOCATION
TOKYO, JAPAN
WEBSITE HORIYASU.COM

Is there a typical Japanese style?
Wabori is the name for traditional Japanese tattoos, where ink is poked under the skin by hand rather than using an electric machine. Wabori images always tell a story.

What do you specialise in?
I only do wabori, and my work takes me around 200 hours per client.

What images do you tend to do?
Tattoos can be light-hearted souvenirs, but many Japanese people get them at a turning point in their life, like if they lose a kid. So I feel a lot of responsibility. I make sure each line is given my fullest attention.
I feel fulfilment, and the client's joy.

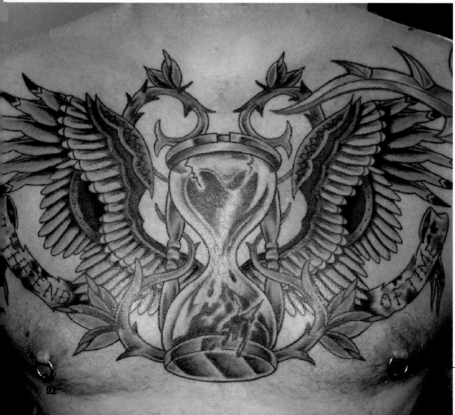

SUZI Q

LOCATION
PERTH, AUSTRALIA
WEBSITE HOLDFASTTATTOO.COM

How did you start?
While getting tattooed in North Carolina, USA, my tattoo artist, Lea Smith of Lucky Lady Tattoo, gave me an apprenticeship.

What do you specialise in?
I'm known for colour work, but I enjoy working with black and grey as well. I like traditional icons – roses, daggers, skulls, nautical themes – and the rockabilly scene.

What's the best tattoo you've ever done?
My new three-quarter sleeve of a modern geisha with fans and cherry blossoms is becoming a firm favourite.

KIAN FORREAL

LOCATION
SYDNEY, AUSTRALIA
WEBSITE INNERVISIONTATTOO.
COM.AU

When and where did you start tattooing?
In Toronto with Crazy Ace, a legend and one of the original bad motherfuckers of American tattooing.

What do you specialise in?
West coast-style script and trad Jap.

Is there a typical Australian style?
Each city seems to have its own thing going on. Up on the east coast it tends to be more 1990s-style tattooing, such as black and grey, faces and demons. In Sydney, people have slightly more mature tastes.

What advice would you offer?
Getting something put onto your skin forever is a serious undertaking, so learn the difference between an OK tattoo and a great tattoo. ⓑ

Blair used a hyfrecator, used in electosurgery

Suz's self-harmed arm and right, Blair's branded version

SELF-HARM COVER-UPS

DON'T TRY THIS AT HOME
IT'S DANGEROUS! IF YOU WANT TO MODIFY YOUR BODY IN ANY WAY, SPEAK TO A PRO

SCARIFICATION, BRANDING AND TATTOOS CAN ALL BE USED TO COVER UP DARK MEMORIES

over-up tattoos are common – people often get a design, but then change their mind and want it covered with another image. Similarly, it's becoming common for people to choose branding and scarification to cover up old self-harm scars.

For example, a BME contributor called Suz sent in some photos of a series of stripes that Blair (one of the world's most celebrated body modders) branded around her scarred left arm. "I met Blair two years ago," she says. "He saw my scarred arm and we got chatting about getting some work done. Next thing I know it's a year later, we have a design planned, and I'm flying back to see him in Canada. It was an experience I'll never forget. I've got a lot of mods, but I've never had one that changed my outlook on my body and how people perceive me.

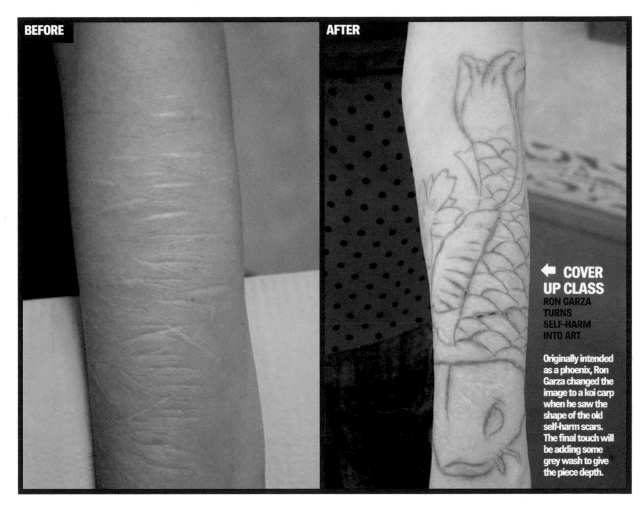

BEFORE

AFTER

← **COVER UP CLASS**
RON GARZA TURNS SELF-HARM INTO ART

Originally intended as a phoenix, Ron Garza changed the image to a koi carp when he saw the shape of the old self-harm scars. The final touch will be adding some grey wash to give the piece depth.

"I'd been self-harming for years, so it wasn't possible to tattoo over the scars. I'd originally thought of skin peels as I've had some done by Samppa Von Cyborg that turned out nicely. However, Blair and I decided to go for a branding using a hyfrecator (medical apparatus used in electrosurgery). With a skin peel the chance of infection would've been too high. This work takes something with negative connotations and transforms it into something beautiful."

Ron Garza, another key member of the body mod glitterati, has done similar work. "I discussed ideas with a plastic surgeon for scar cover-ups executed the same way tattoo cover-ups are done, but on a larger scale," Ron says. "He suggested that we consult surgeons to discuss the possibility of making medical scars into designs, decided on by the patient before the operation."

SOMETHING NEGATIVE IS TRANSFORMED INTO A THING OF BEAUTY

"This piece (above, right) was a way of covering over self-injury scars and allowing the wearer to have a fresh beginning. Originally a phoenix was requested, but when we started drawing the design a koi carp seemed to fit with the old scars better. I removed some of the old tissue to level the skin, and tried to create a level scar in a field of uneven skin. When we add some grey wash to the work it'll give the entire piece more depth and really take the emphasis off the old scars." Ⓑ

MEET THE ONLY MAN WHO RAN AWAY FROM THE CIRCUS TO GO BACK TO SCHOOL

WORDS **MARC HARTZMAN** PHOTOS **NEVILLE ELDER**

EAK THE GEEK

or the average law student, the thought of spending time sleeping on a bed of nails rather than revising for your bar exams may sound like lunacy. But Eduardo Arrocha – a freshman at the Thomas M Cooley Law School in Lansing, Michigan – is anything but average.

Better known as Eak The Geek, the 45-year-old tattooed wonder was a performer at the Coney Island Circus Sideshow in New York – often under the monikers The Pain-Proof Man and The Man Who Tattooed His Face Like Outer Space – where his act involved walking on broken glass and inviting audience members to stand on his chest while he was sandwiched between two beds of nails. These incredible skits were punctuated by poetry readings and lectures on the importance of diversity.

However, now Eak's ditched his life on stage in favour of the classroom. Armed with a BA from New York's Marymount College, he's packed up his bed of nails and moved to the land of Great Lakes to pursue a new career. We caught up with Eak to talk about the pressures of running away from the circus to become a lawyer…

How did you get into sideshow performance?
It started in 1981 when I sold balloons at the Albuquerque state fair. The people who worked there took me under their wing and taught me how to hustle. Before long, I dropped out of school. I travelled around the USA for a while doing odd jobs, playing in hardcore bands and writing poetry. Eventually I ended up in New York and hooked up with the people who ran the Coney Island ➡

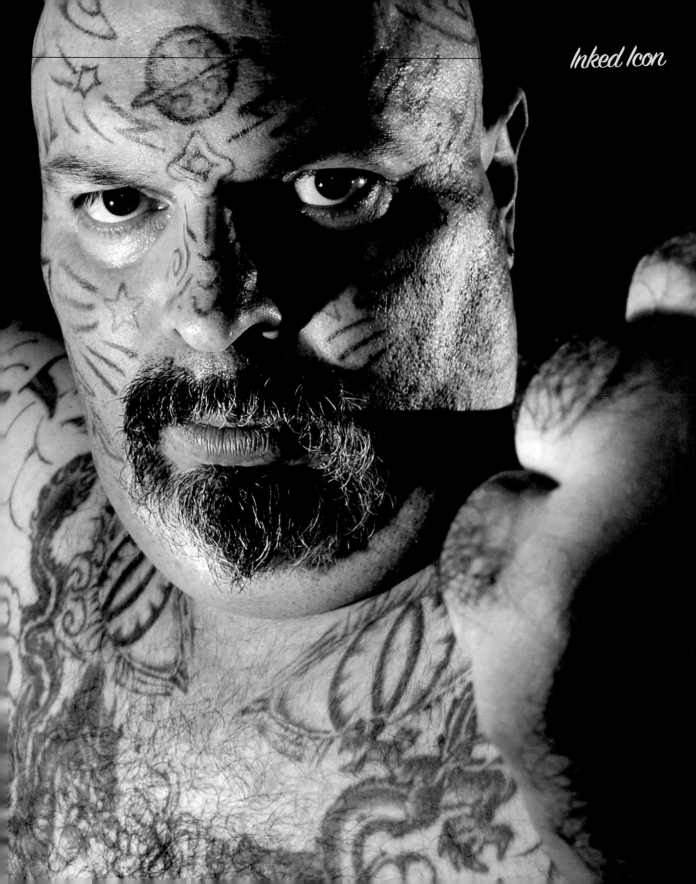

sideshows. I was soon working outside the shows, persuading people to come in. It was the perfect job for me – managing cash flow, moving people in and out. I really liked the rawness of Coney Island at that time – it was crazy. You'd see the transvestite whores giving blowjobs to the wiseguys, and bet on how long it would take for them to get off. You saw a lot of rumbles between gangs. The whole boardwalk would be quiet, then – boom! – 50 seconds of violence and mayhem. It was really exciting.

Have you always felt like an outsider?
I've always been somewhat of a freak. I never belonged to any scene. Even though I hung out with hardcore musicians a lot, I was always my own unit. So I felt like the sideshow was a place where I belonged.

Tell us about your facial tattoos.
The first tattoos I had on my face were the shooting stars on my forehead. I'd thought about tattooing my face for many years, but was caught between two worlds; I worked for the sideshow, but I didn't want to go too far and dishonour my parents. I knew that a lot of people who tattooed their face ended up becoming junkies, alcoholics or just very anti-social. It was about 10 years before I decided to go through with it.

Eak meets some actual geeks

What changed your mind?
One summer while working in the sideshow, I went crazy for this girl. We hung out for months, but as spring came around and my work came to an end, she said, "I don't want to lead you on – I just want to be friends." It was a shock to me, and I realised the sideshow had a lot to do with it. I was cool to hang out with when I was working – but when I wasn't, she didn't want to know me. And I thought, "Why am I holding back? I'm never going to be accepted by the normal world."
So I told myself to just go for it.

"I REALISED I WAS NEVER GOING TO BE ACCEPTED BY THE NORMAL WORLD"

Nonetheless, it must've been a tough decision.
I was scared, because it was such a huge commitment. I wasn't even sure I wanted to be a walking freak show. It took me two more years after that before I did it. I kept working in the sideshow and toying with the idea.

What happened when you finally took the plunge?
When I finally tattooed my forehead, I just wanted to keep on selling tickets outside the sideshow. But at the end of the year my managers told me I'd ➡

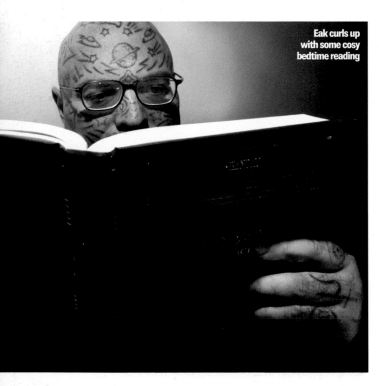
Eak curls up with some cosy bedtime reading

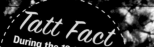

Tatt Fact

During the 19th century, soldiers deemed 'bad characters' by the British army had 'BC' tattooed on their wrists

VICTOR

Tatt Fact
The Halba, the workers' caste of India, believe "tattoos are the only jewels a girl takes to her grave"

have to become part of the show, because I was a freak and shouldn't work front of house. However, I didn't really want to become a sideshow object, and didn't return to the sideshow that year. I was under intense psychological stress because I knew that I'd have to come up with an act to continue working. But I didn't want to stop being who I was when I got inside the theatre.

Sounds like it was a tough time for you…

It was, but I needed that time to reconcile what was going on in my life. I became a lot happier afterwards. Before that, I was a mean bastard. I was a conservative guy, but when I got drunk I'd do outrageous things to draw attention to myself. That's where the name Eak comes from – it's short for 'Eddie Are you Kidding?' That's what people would say to me when I misbehaved. The name was also part of reinventing myself – Eduardo Arrocha from Mexico City transformed into Eak The Geek the sideshow freak. I think reinventing my name and character saved my life. I'm still Eduardo, but once I tattooed my face I stopped being embarrassed about my identity. Suddenly I couldn't reinvent myself any more – I used to do it all the time, but with facial tattoos I couldn't. I finally accepted who I was. I didn't do it for the sideshow, and that's why I have to take some time off from it.

So you've now left the sideshow behind and gone back to law school. Was that hard at first?

It was tough initially because I got way too much attention – and the local paper made things worse by running a front-page story the moment I hit town! The

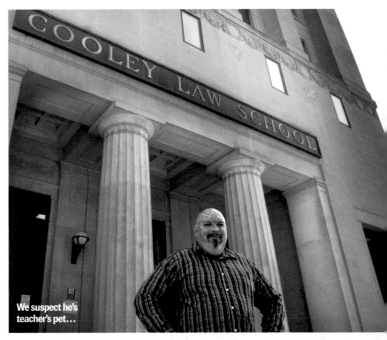

We suspect he's teacher's pet…

"GOING TO COLLEGE WAS THE MOST BIZARRE THING I'VE DONE IN MY LIFE"

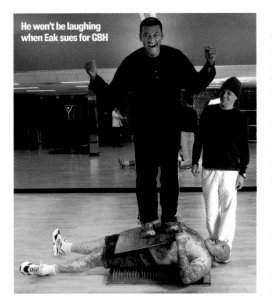

He won't be laughing when Eak sues for GBH

people in Lansing had never seen anybody like me. They freaked out! They weren't nasty – just really shocked.

Do you ever feel that entering an institution like law school is a challenge to your individuality, which is clearly important to you?

If you're tattooed like I am, you're not really a trailblazer in the sideshow. Going back to school and then moving on to law school – now that's real trailblazing! If you look the way I do, it's no surprise you work for a sideshow. That's what people expect. But if you look like me and you're in law school, that's a shocker.

And how does studying compare to lying on a bed of nails every night?

It's like nothing I've ever done. And that's an understatement. Nothing prepares you for it. They really let you have it in the first year, there's so much to learn. It makes the sideshow look like a piece of cake. It's the most bizarre thing I've ever done in my life. Now I tell people I went from one freak show to another. ⑬

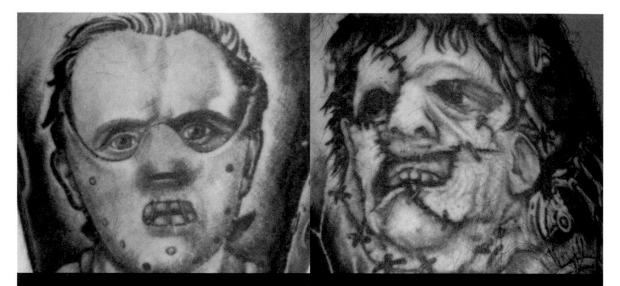

HORROR

SCARY IMAGES ARE STILL A FAVOURITE WITH READERS

JAY DOWNS

Who did it? I did some tattoos myself, I'm self-taught, but my others were done by various artists.
What is it? A full bodysuit, 32 piercings and a dermal anchor in my forehead.
Why did you choose it? To be different.
What response do you get? Some people love the work I've had done and ask me about it. Others pretend I'm not there and treat me like shit.

JAY DOWNS

Who did it? Clem Laurell from Kingtat Graphix, Tulsa, USA.
What is it? The mugshots of Moors murderers Ian Brady and Myra Hindley.
Why did you choose it? I've been getting serial killer tattoos for years, and this has always been one of my favourite cases. I even sent a picture of it to Ian Brady at Ashworth Hospital.

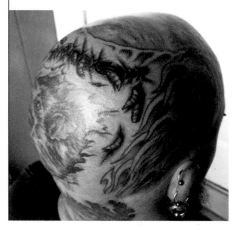

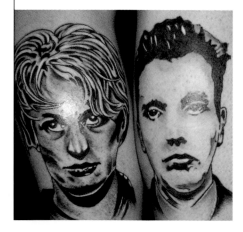

BARRY KERR

Who did it? Snoopy at Tattoos by Snoopy and Pussifer, Northern Ireland, UK.
What is it? The head of Frankenstein's monster.
Why did you choose it? Since I was a kid I've been a big fan of Frankenstein movies, especially the old Boris Karloff flicks. Now I'm planning to get a Bride of Frankenstein tattoo to keep him company.

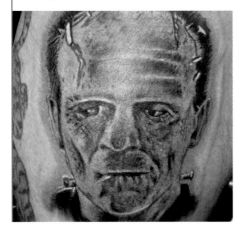

JANE DAVIDSON

Who did it? Jason Goldberg at Olde City Tattoo, Philadelphia, USA.
What is it? A hand-drawn voodoo rag doll.
Why did you choose it? I've had a streak of bad luck lately, and suspect I've been jinxed. My doll looks like how I feel! Plus I wanted something unique and Jason's an amazing artist, so I knew whatever he'd do would be killer.

LINDA BELL

Who did it? Max at Custom Inc Tattoo Studio, Glasgow, UK.
What is it? The first part of vampire sleeve.
Why did you choose it? I love vampires.
What response do you get? People either love it or hate it. I get the odd horrified glance, and I've even scared a small child – class! I plan to get more work and wouldn't change anything. ➡

MARK SMITH

Who did it? Gary Harper of Dream Warrior Tattoos, Barnsley, UK.

What is it? A tattoo of horror flick *The Exorcist*.

Why did you choose it? Because it's a scary tatt that stares right through whoever looks at it.

What response do you get? People think it's scary, but then marvel at the lifelike image of actress Linda Blair as a possessed child.

MITCH BARRETT

Who did it? Vaz at Skin Shock, Croydon, UK.

What is it? It's the first part of my sleeve, showing a nail going through my wrist – nice and pretty! I also have the devil as played by Dave Grohl in *Tenacious D In The Pick Of Destiny*.

Why did you choose it? To look badass, and because the movie is a classic. All the elements fit in well with my plans for the rest of the sleeve.

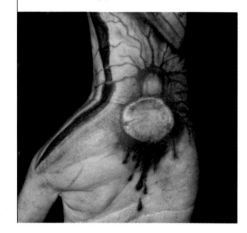

SCOTT STEPHENS

Who did it? My good friend Matt Gardiner at Tattoo U, Cardiff, UK.

What is it? Characters from the movies Dead Silence and The Puppet Master.

Why did you choose it? I loved The Puppet Master movies when I was younger, and thought the characters would make awesome tattoos. It was Matt who suggested a half-leg piece.

STAINS

Who did it?
Rob Dixxx at Yankee Tattoo, Burlington, USA.

What is it? The '666' from The Omen, but done like it was carved with a razor, then got infected.

Why did you choose it? I'm a special effects artist, trained at Tom Savini's school, and I love horror! I wanted to get something that looks like the effects I create for people in the movies.

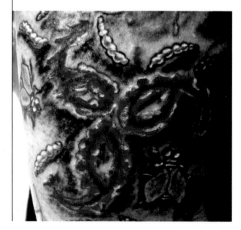

DAVE DENT

Who did it? Low at Northside Tattooz, Whitley Bay, UK.

What is it? The start of my horror sleeve, including Freddy Krueger and Pinhead.

Why did you choose it? I wanted a classic horror sleeve, so I just chose my favourite icons of the genre and let Low work his magical magicness. It was my first big tattoo.

TERRY HAWKINS

Who did it? Carl Collinson at Urban Image Tattoo Studio, Dorset, UK.

What is it? A horror movie sleeve. I have Michael Myers, the creature from *An American Werewolf In London*, Frankenstein's monster, the Bride of Frankenstein, the Phantom of the Opera, Billy the jigsaw puppet, Jason Voorhees, Leatherface, Wednesday Addams… and more!

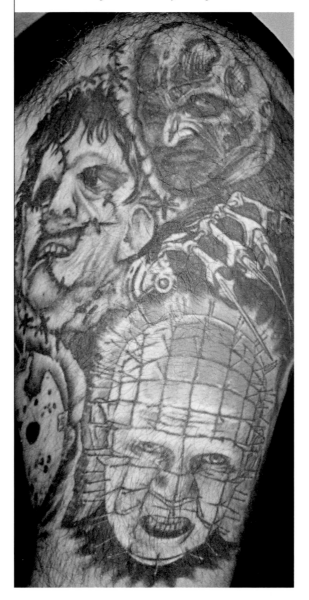

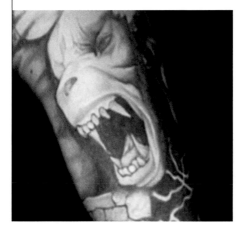

JENNIFER SMITH

Who did it? Lenny Renken at Black 13 Tattoo Parlor, Nashville, USA.

What is it? Trash from *The Return Of The Living Dead*. It's one of my favourite movies.

What response do you get? People love it.

What do your family think? They hate it.

What other ink have you got planned? I'm hoping to get horror movie sleeves. Ⓑ

Tattoo artist Tony Diablo
with wife Kta, and (fake)
tattooed kids, at the New
York Tattoo Convention, 2008

DEFYING
Convention

WHETHER YOU'RE AN UNMARKED VIRGIN OR A WALKING TAPESTRY, TATT CONVENTIONS HAVE IT ALL: BLOOD, BEAUTY AND A LOT OF BUZZ...

WORDS **ALIX FOX** PHOTOS **NEVILLE ELDER, ASHLEY**

After a truly buzzing day out? Then get yourself to a tattoo convention. One of the first things you'll notice as you step through the doors is the burring noise coming from the hundreds of vibrating tattoo machines, humming louder than a chamber choir suffering from amnesia. But if you're considering committing yourself to some permanent ink, it's well worth putting your eardrums through the torture as talking to tattoo professionals and enthusiasts is one of the best ways to make sure you end up with an emblem you love, rather than spending the rest of your life desperately scrubbing your dermis with Daz. Here are a few tips on what to expect from modern conventions, and how to make the most of the opportunities they offer. ➡

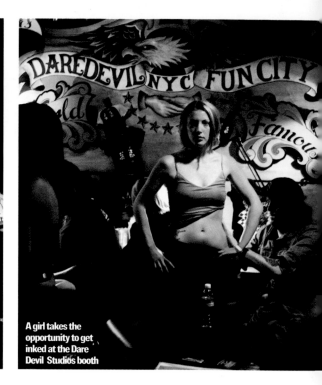

An artist sketches out new designs while being worked on in public at the New York Tattoo Convention, 2008

A girl takes the opportunity to get inked at the Dare Devil Studios booth

STAND AND DELIVER

SO WHAT'S ON THE MENU?

■ Conventions bring together tattooists from all over the world. Each studio or artist has their own stand where they exhibit photographs of their work, chat to guests, and may also tattoo live – so you can get a piece done there and then, or use the event as a reconnaissance mission to gather inspiration for the future.

■ They normally feature a series of tattoo competitions – judging ink under categories such as 'best black and grey', 'best sleeve' and 'best portrait' – that consider both pieces completed before the event, and work done within a strict time limit during the show.

■ You'll also be treated to stalls selling tattooing equipment and supplies, jewellery, clothing, food and drink, plus more unusual wares to spend your cash on. Over the years we've seen all sorts getting hawked, including hand-crafted tattoo machines, stained glass windows and loo seats with flash illustrations on the lids!

■ Aside from perusing portfolios of designs and watching folk get incredible sketches etched on their shoulders,

shins and shaven heads, there's plenty of entertainment on offer. Exactly what's laid on to colour you happy varies according to the size of the convention and how well established it is – but expect fashion shows, bands, performances from burlesque and sideshow stars, and meet-and-greet sessions with inked idols.

■ Many conventions also feature workshops and talks on tatt-related subjects, but these often require you book a place in advance or are only open to those working in the business; in fact, some exhibitions have entire days that are trade only, so check beforehand to avoid rocking up at the venue, only to be turned away because you're not a professional needle-wielder.

■ Increasingly, experts in alternative body modification techniques such as branding and scarification are starting to hold stalls at tatt shows, although so far we've only seen them talking about their art, rather than performing procedures in front of crowds. Tattoo removal and cover-up specialists often have stands too, so conventions can be brilliant places for sussing out your options if you've already got a piece you regret. ➡

Tatt Fact
Members of the Nazi SS had their blood type tattooed under their armpits in case of injury

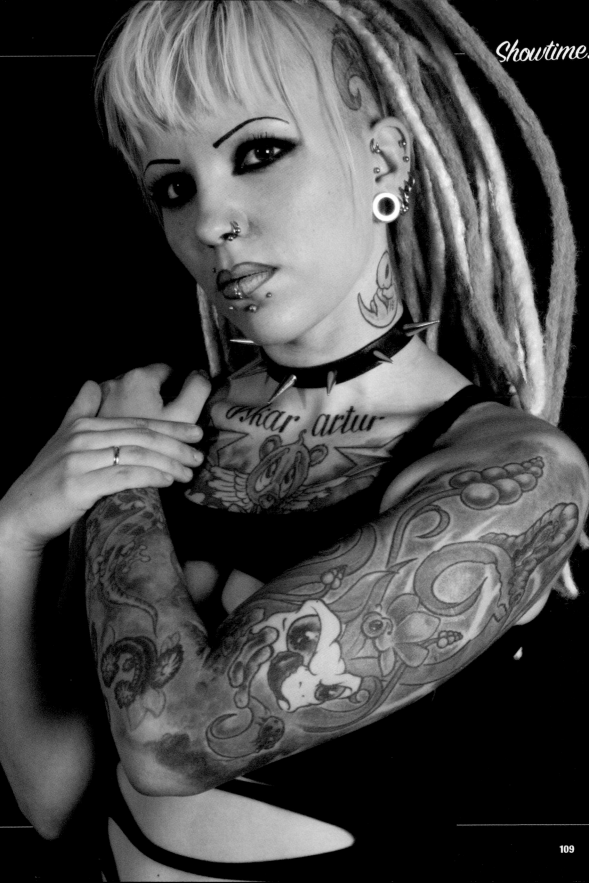

BEFORE YOU INK

**PLANNING TO GET A TATTOO ON THE DAY?
READ THIS BEFORE ROLLING UP YOUR SLEEVE**

■ If you're sure of the design you want and who you want to draw it, conventions can be a great way to get a piece done by an artist you'd normally have to travel miles and cross continents to visit. However, tattooists differ in what ink they'll do at shows; some prefer to undertake commissions only from people who approach them on the day, to make the experience spontaneous and exciting for them, while others insist tattoos are pre-booked so they can accurately plan their time. Find out what your chosen artist's plan of action is – contact details for each exhibitor are listed on the convention's website – and either way, get in early: pre-booked and walk-up slots fill up fast for the most talented machine-manipulating maestros.

■ It's one thing getting a bit of black work in the quiet backroom of a tattoo parlour, and quite another getting a biomechanical butterfly tapped into your buttock in front of a gawping crowd. If you're someone who needs a calm environment to get tattooed, then choosing to be inked live might be unwise. Can you take the pressure of having an audience watch you wince and sweat? If you can't, hold off on becoming a live exhibit.

Tatt Fact
The 19th century French penal tattoo of three dots across the thumb means 'death to the police'

■ Don't plan to hurry home at the end of the day; there's almost always an aftershow party going on at a local bar, and there are often pre-show shindigs organised too. Find out whether you need to buy separate party passes in advance, and consider booking overnight accommodation if you live a fair way from the event site – conventions sometimes run special offers with local hotels.

■ Just as drinking and driving is a big fat NO, so is inking and driving. If you've just had a big back piece done, getting rubbed raw by car seat velour won't hold much allure. As well as uncomfortable, it can also be dangerous; when the adrenaline leaves your system after a session in the tattooist's chair, it's common to feel tired. And if you're knackered, you're more likely to have an accident.

■ By their nature, conventions are loud, busy affairs with a fair amount of blood, and it's not unusual to encounter the odd topless woman getting a chest piece done. So they're not always appropriate for kiddies – and many bairns get bored with all the walking, waiting and watching anyway. Some conventions positively embrace families and even provide crèches, while others recommend that you leave the little 'uns at home, or in rare cases even forbid under-18s entirely. So find out what the deal is before you start packing the Pampers. ➡

Show-offs and exhibitionists abound!

Sabina Kelley at a convention – look out for celebrity guests

Wear your walking shoes, keep a map and don't forget a sensible flask of warm tea

VISITATION RIGHTS
GET THE MOST OUT OF YOUR DAY, WHETHER YOU'RE GETTING INKED OR JUST GAWPING

■ Make sure to grab a separate site map and timetable for everyone in your group as soon as you arrive – you're bound to get split up as one person stops to watch a demonstration while another gets caught up in conversation. Agree a set meeting place and time for later in the day, and make sure everyone's mobiles are fully charged.

■ Cash machines aren't always available on site, and many tattooists and vendors accept cash only. So make sure you have enough wonga before you wander over.

■ The internet means that it's relatively easy to have a gander at pictures of artists' creations and get a feel for their style, wherever they're based. However, it doesn't compare to actually meeting them – and this is where conventions truly come into their own as you can directly discuss ideas and get the measure of an inker's ethic. Talk to tattooists, glean as much info as you can and see which characters you rub along best with – but be careful not to interrupt or distract them if they're trying to concentrate on decorating someone, unless you want to be on the receiving end of an aggravated knuckle sandwich.

■ You wouldn't get tanked on tequila before you had a tattoo in a standard studio, so if you're planning to get inked on the day, don't sink too many sambucas. Alcohol makes you bleed more, and artists may refuse to work on you. Watch what you drink the night before, too.

■ If you're lucky enough to appear young, take some ID with you – if you seem underage, no reputable artist will touch you with a bargepole, let alone a needle. ⓑ

Tatt Fact
In 2002, Pamela Anderson revealed she'd contracted Hepatitis C from sharing a tattoo needle with her ex-husband Tommy Lee

The lesser-spotted gambling fish

Fish suppliers in Hong Kong are using low intensity lasers to tattoo fish scales

Body Mod Masterclass No.5
PET MODS

THE PRACTICAL AND MORAL ISSUES BEHIND MODIFYING ANIMALS

Piercing a pet fish sounds sick, right? Many would even consider it abuse. However, humans have a long history of modifying animals with everything from identification tattoos and brands to cosmetic surgery such as ear cropping and toe amputation (or 'declawing').

We pierce the ears of cattle to hold ID tags and anglers give fish permanent lip piercings, not to mention the mass imprisonment and killing of animals in the food industry. Many animal lovers decry the animal body mods shown here as barbaric but, unless we're vegans, when it comes to animal abuse most of us are involved in worse treatment being forced on animals than simple piercings.

Still, is piercing a fish acceptable? Pro piercer William from Arizona sent BMEzine.com pictures of his fish with a labret (a small piercing below the bottom lip). He said it

William's pierced goldfish, reflected in the water used to fill his bowl

started as a joke, but "as it didn't affect the goldfish adversely" he left it in. He claims the fish didn't suffer.

"Goldfish have a 30-second memory. And how many live fish are there out there with hooks stuck in them? At least this one had jewellery," says William. "The fish seemed unaffected. He ate normally, and the piercing didn't weigh him down or affect his ballast."

William used a 5mm labret with a light acrylic end and did the piercing freehand while his apprentice held the fish, which was taken out of the water, then put back straight after. William says he'd pierce a fish again. "As long as it was of substantial size," he adds. "I've been asked to pierce Siamese fighting fish, but there's no way. If I did, I'd only charge for the jewellery, not the service."

As well as piercing, fish have been on the receiving end of tattooing. Some fish in an Oklahoma pet shop were

THE PIERCING DIDN'T WEIGH THE FISH DOWN OR AFFECT ITS BALLAST

seized by police after being vibrantly inked and sold to punters – and the Humane Society Of The United States maintains the practice harms the animal.

As far as the morals of pet modification are concerned, draw your own conclusions. But while William's procedure appears to have been a success, attempting the same with cats, dogs or other animals is likely to end in them gnawing or scratching out the piercing and injuring themselves in the process. Ⓑ

PICTURES: BMEZINE.COM

115

MEET THE PORN-LOVIN' RETIREE
WHO'S THE FIRST LADY OF EXTREME INK

WORDS AND PHOTOS **ASHLEY/SAVAGESKIN.CO.UK**

Isobel
VARLEY

sobel Varley was born in 1937, which means she's an impressive 70 years old. But she's not clipping coupons or shuffling off to bingo just yet. Instead, Isobel is the most tattooed pensioner in the world. She travels the globe as guest of honour at inking conventions, hangs out with people with bolts through their necks, and has penises tattooed on her head. She's spent £20,000 ($31,800) on ink and 500 hours under the needle, and in 2000 was acknowledged by *Guinness World Records* to be 'The World's Most Tattooed Senior Woman'. Respect.

What prompted your first tattoo?
In 1986, when I was 49, I went to a tattoo convention in London with my husband Mac. I was struck by the beauty of the tattoos and the diversity of the people who had them. I got my first tattoo a few days later. It was done by Bill Cooke, who's since sadly died. I chose a small bird to sit on my right shoulder blade. Much to Bill's surprise, I then asked him to do another one for me – an orchid on my left thigh – straight away.
And now you have full body coverage.
Yes, though it was never my intention. After my first tattoos, I went to another artist who did a couple of bits of work on me. But when I went to Brent of Dunstable, he said he thought I was getting too many small pieces. So he started ➡

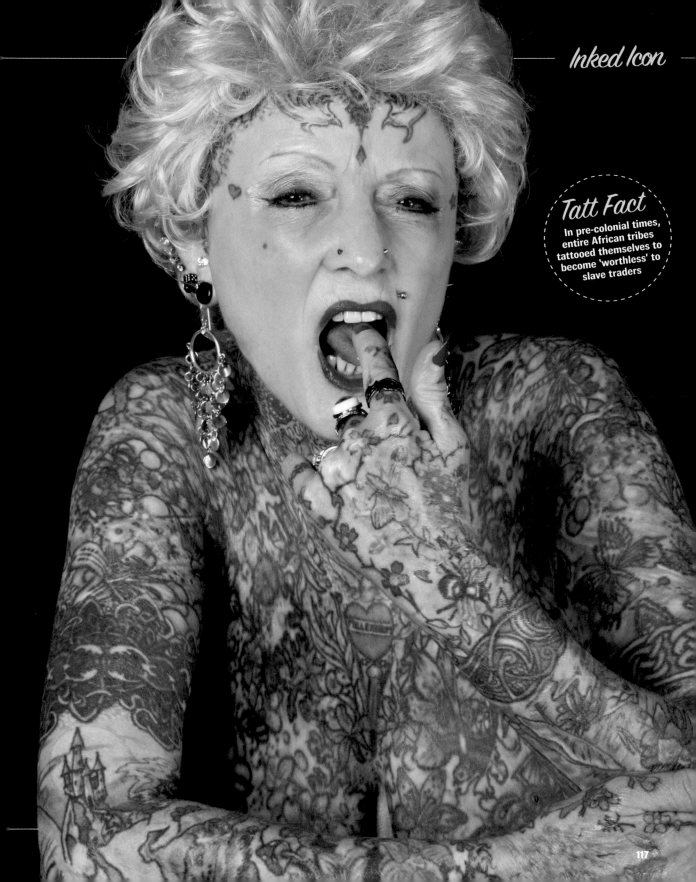

Tatt Fact

In pre-colonial times, entire African tribes tattooed themselves to become 'worthless' to slave traders

to join them up, and that's how thebodysuit began. We started at the top of my body and worked our way down. So many people get bits and pieces that have no connection, which can look messy.

You recently got your head tattooed with penises and mice. What inspired that?

My head was tattooed by Paul O'Connor, who's done a significant amount of work on my body. I gave him free rein to do whatever he wanted. After he'd been working for about half an hour, I got really curious and asked him what he was doing. He said, "I've done some cocks up the back of your head." The cheeky old so and so.

What themes run through your work?

Most involve flowers, wildlife or erotic imagery.

Tell us about the erotic imagery…

Well, apart from the ones on my head, I've got other cocks around my body. On my stomach, just above my genitals, I have a tattoo of a mouse escaping from a cat into my hole. Above that are the words, 'Hungry Pussy'.

What kind of reaction do you get in the street?

Children mostly just look and don't say anything, but teenagers are

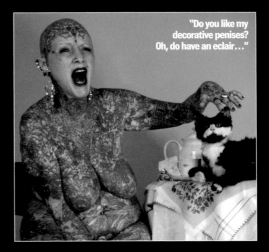

"Do you like my decorative penises? Oh, do have an eclair…"

often really interested and say, "Wow!" if they notice my neck or hands. With older people, reactions vary. When I was on holiday in Majorca, I befriended two elderly ladies. I generally wear minimal clothing, but they'd never commented on my tattoos. Then one of them accidentally brushed against me. She seemed startled and said, "Ooh! I thought you were wearing a flowery blouse, I had no idea the flowers were on your skin!" She asked if the colours could

"I FIND PIERCINGS IN MY GENITALS HUGELY EXCITING!"

come off! These ladies were old-fashioned, but they studied my tattoos and told me how lovely they thought they were.

How have your family reacted to your tatts?

My son and most of my relatives accept it now. When my mother was alive, she'd always be concerned that I'd catch something from the needles.

Have reactions changed much since you've had more work on your neck, head and face?

I've noticed people looking more since my forehead was done, but that's inevitable, really.

Do you get many negative comments?

Thankfully not. I've had one or two emails from people who don't like what I've done, but I don't take any notice. I love my tattoos and they've enriched my life. I've never travelled as much as I do now.

Are tattoos addictive? Is that what drives you to keep getting more done?

Probably. Once you start something, it has to be finished — things just seem to develop by themselves. ➡

Tatt Fact

The criminal tattoo 13 1/2 stands for the judge (1), the jury (12), and the half-assed sentence

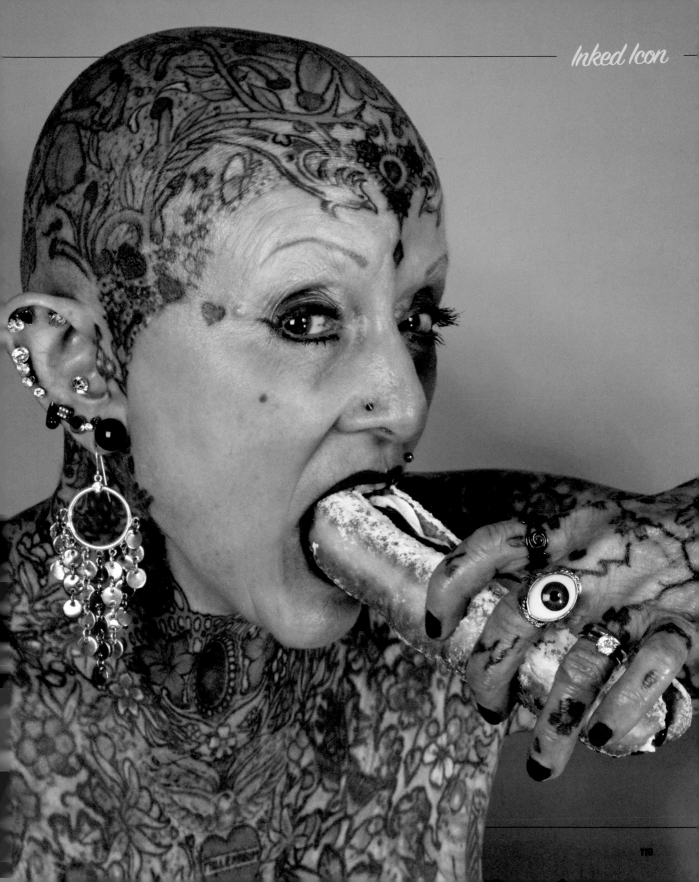

SO VARLEY SO GOOD!

SHE'S CREAKY BUT SHE'S FREAKY…

1986
Isobel gets her first tattoo – a bird on her shoulder blade.

1987
She's hooked instantly, and soon one breast is well-inked.

1993
Work starts on Isobel's favourite piece: Her belly tigers.

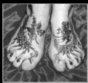

1995
"I love my flowers, but they were incredibly painful."

2000
Famous US artist Spider Webb inks a signed arachnid.

2004
Yushi Takei reworks Isobel's forehead artwork.

2006
"Paul O'Connor's surprise! I didn't see it until he'd finished!"

Which areas are the most painful to tattoo?

As the tattoos have progressed down my body, the level of pain has increased. The tops of my feet were only just bearable, but having my vulva tattooed by Alan Dean was the most painful, particularly when it came to the inner labia and the clitoral hood. In my opinion, this work was necessary to complete the bigger picture, but I'm not sure if I could endure that level of discomfort again.

Aside from tattoos, you have lots of piercings…

I've got a total of 48 at the moment, which include two in my nostril, one in my lip, one in each nipple, one in my navel and 28 ear piercings. The rest are genital piercings – three in each inner labia, two in each outer labia, and four in my clitoral hood. I have to admit, I find all these extremely exciting and hope to keep them indefinitely!

Do you have any friends in your age group who are also heavily tattooed or pierced?

I know Prince Albert, of course. We occasionally meet at conventions, and it's nice to catch up and chat. Most of the older tattooed people I know tend to be the ones I meet at conventions. But as they're spread around the world, we don't get together that often.

Do you have a favourite tatt?

The family of tigers on my stomach is one of my favourites. It's really beautiful and I love wildlife.

Which of your tattoos make you laugh?

The cocks on my head!

"Got my dildos, got my stuffed bears – all set for a quality night in."

"I HAVE PENISES AND MICE INKED ONTO MY HEAD!"

What advice would you give to youngsters intending to get lots of tattoos?

It's a personal thing, really. You have to decide what you want in the early stages, or you can end up with bits and pieces all over your body that may not work together. Some people still judge those of us who have visible tattoos, and that must be an important consideration for youngsters. Ultimately, though, it's about individual choice.

As an ambassador for the tattoo community, is there anything else you'd like to say?

I think it's great that museums, academics and the art world are finally recognising the importance of tattoos within today's society, but I'll never push my tattoos onto anyone. I understand there'll always be people who don't like them. There's often been a tendency to look down on people with visible ink. This will hopefully change now that more people have them. I imagine tattoos will increasingly be seen as acceptable – though I'll always be the extreme, I think I'm inoffensive and extreme. ⑬

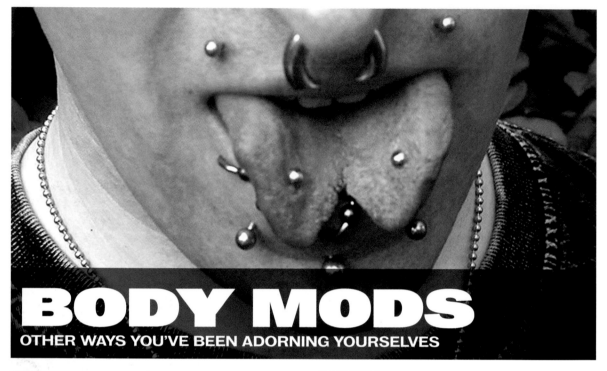

BODY MODS
OTHER WAYS YOU'VE BEEN ADORNING YOURSELVES

NICOLA DUFFIELD
What is it? The middle heart is strike branding done 12 months ago, and the tribal around it is skin removal done about four months ago.
What response do you get? Most people look horrified and ask how I could pay someone to do that to me! The occasional person likes it, but then says it isn't for them. If my parents knew about it, I'm sure a coronary would be in order!

ZEROLUIE
Who did it?
Kate at Holier Than Thou, Manchester, UK.
What is it? A microdermal or surface anchor.
Why did you choose it? I considered transdermal implants, but was concerned how some fail to heal properly. So microdermals were the best for me.
What response do you get? People want to touch my face to see if they're real!

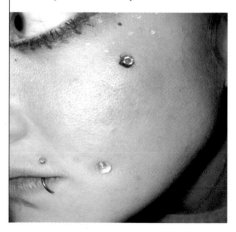

SPOOKY VON GLITTER

Who did it? Artists at Jolly Roger Tattoo and Indigo Tattoo, both in the Norwich area, UK.

What is it? Lots of different piercings, including seven in my ear, one in my nostril, one septum piercing, pierced tongue… and more!

Why did you choose it? Metal makes me pretty!

What response do you get? I get a lot of rude comments, especially from chavs.

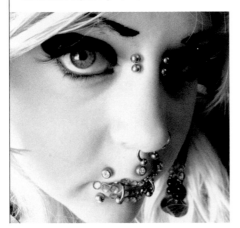

PHILLIP GREEN

What is it? Lots of body mods, including split tongue (see above, left) and stretched earlobes.

Who did it? I did the tongue splitting myself with two piercings and fishing wire – it took a few months to complete.

Why did you choose it? I love the fact my split tongue is natural looking. It's my only mod that's purely organic – no ink, no metal, just flesh.

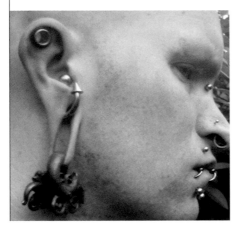

LURELLE DE-GISI

What is it? A big septum piercing.

Why did you choose it? When I was 16, I was the only person in York with a big septum piercing. But then I saw loads of other people getting them, so I decided to go even bigger. No one has dared to follow me!

What response do you get?
My mum thinks I've lost the plot. ➡️

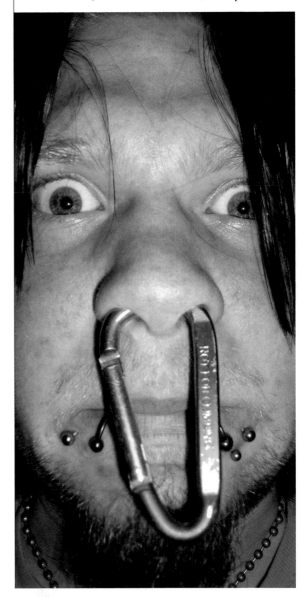

Your Mods

ELLIS HOWE

Who did it? Most of my piercings were done by PX Piercing Clinic, and my naval and tongue were done at Hype Tattoo Studio, both in Newcastle upon Tyne, UK. I did a couple on my ears and my right nipple myself!

What is it? I have a total of 16 piercings, and the first holes on my earlobes are expanded to 10mm.

Why did you choose them? I like how they look.

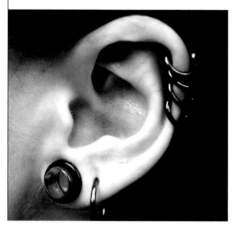

FRANKIE MILLS

What is it? A third eye piercing, along with two eyebrow piercings and two in my lower lip.

Why did you choose them? I like to be creative and do something different.

What response do you get? "Eek! Did that hurt?"

Are you planning any more work? I'd like to pierce the side of my neck, but can't decide whether to get three or four.

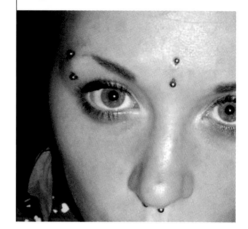

KRISTY PFANNENSTIEL

Who did it? Kari at Kari Barba's Outer Limits Tattoo And Body Piercing, California, USA.

What is it? Set of nipple piercings.

Why did you choose it? I went online looking for nipple tassels after seeing Elvira, I saw a nipple shield for the first time and loved the jewellery. I read about the procedure and possibilities, then got them done when I turned 18.

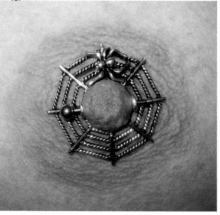

STITCHES

Who did it? Most of my piercings have been done by Al from Steve's Tattoo Studio, Ipswich, UK, but I've done a few myself.

What is it? I have 26 piercings in total, lots of them in my face.

Why did you choose it? They're a huge part of who I am. I have to remove them for work, and don't feel like myself at all!

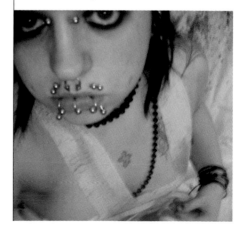

RICHARD MURRAY

Who did it? Access All Areas in Nottingham, UK.

What is it? An autopsy scar.

Why did you choose it? I suppose what inspired me was the shock value, and that I hadn't seen anyone else with one. I've seen someone else with an autopsy scar now, but mine is slightly different – it's more natural, not a perfect cut, as it were.

LORI

Who did it? Mac at Punctured Body Piercing and Modification, Devon, UK.

What is it? Four stars which were branded, with swirls coming off them to look like shooting stars. The smaller swirls were cut in, and for the larger ones the skin was removed.

Why did you choose it? Reading about body modification in Bizarre!

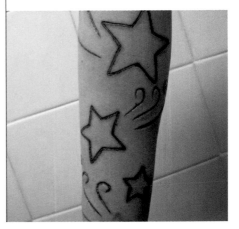

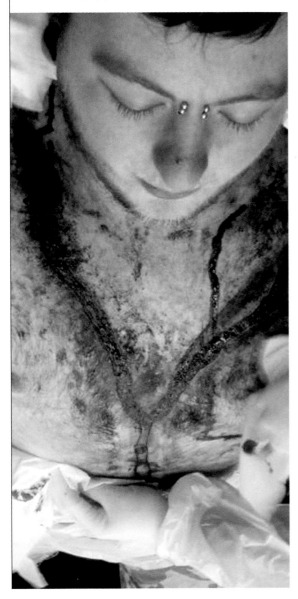

CHARLOTTE CARR

Who did it? Pete at Kazba, Leicester, UK.

What is it? Chest surface piercing.

Why did you choose it? I wanted something different that can be made visible when I choose, but easily hidden at work.

What response do you get? The most common is, "That looks painful!" But most people like it.

How do you feel about it now? I love it! Ⓑ

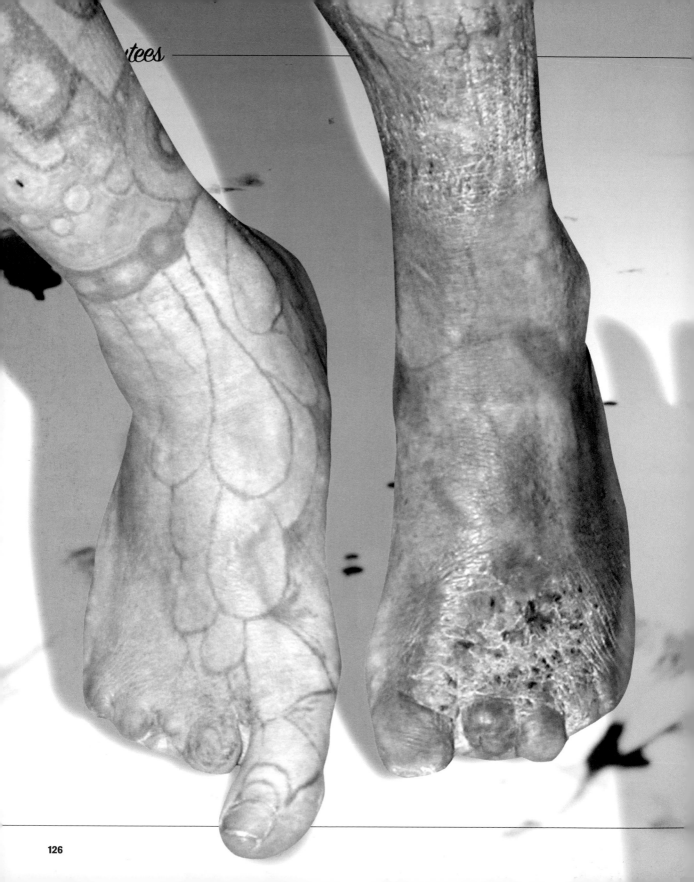

MEET THE PEOPLE WHO DON'T FEEL COMPLETE UNLESS THEY LOSE A FINGER, LEG OR TOE

OUT ON A LIMB

WORDS **DENISE STANBOROUGH**

One sunny Florida morning in 2001, George Boyer reached the end of his tether. After 18 years of suffering in silence, he decided to take matters into his own hands. Cocking his gun with shaking hands, Boyer sat in his backyard, aimed the gun at his leg, gritted his teeth, and blasted a hole right through it. Later, after reaching hospital, doctors were presented with a baffling dilemma. Rather than wanting his leg to be saved, Boyer begged for it to be amputated, even though the limb was salvageable.

By shooting himself in the leg, Boyer was acting out a long-term desire to be an amputee – a desire he'd had since he was a child. He'd spent years planning for that morning, swotting up on safety measures and practising his aim on shoulders of pork. In an interview with one newspaper, Boyer explained his desire to go to extremes. "I've wanted to be one-legged since I was a child," ➡

he said. "No one can help this overwhelming and irrational wish that I've experienced with varying degrees for as long as I can remember. Now for the first time in my life, I'm finally happy."

'ARMLESS FUN?

George's case is not a one-off. A few years earlier, Dr Robert Smith hit UK headlines after removing a healthy limb from each of two patients at a Scottish hospital. One of the men, Kevin Wright from Essex, had his lower left leg removed at the Falkirk and District Royal Infirmary in September 1997. In a post-op interview he told the press, "I just didn't want it. By taking that leg away, the surgeon has made me complete." After searching for a surgeon willing to perform an elective amputation, Wright was lucky enough to find Dr Smith. Others, like George Boyer, have resorted to more desperate measures.

Dr Michael First, one of the world's leading experts on psychiatric diagnosis and assessment, has become the first person to carry out a detailed study on voluntary amputation. Approached by a TV producer looking for people to appear in a documentary, First was introduced to what he'd later term Body Integrity Identity Disorder (BIID). "I was shocked," he says. "Initially it sounded like Gender Identity Disorder, but I realised we'd come across a new mental condition. I decided I wanted to investigate it further."

Tatt Fact
According to Inuit legend, when un-tattooed women die the gods of the afterlife use their skulls as drip trays for candle wax

"I'M CURRENTLY CONSIDERING PARALYSING MY OWN LEGS – BUT I'M NOT SURE IT THAT WOULD BE ENOUGH FOR ME"

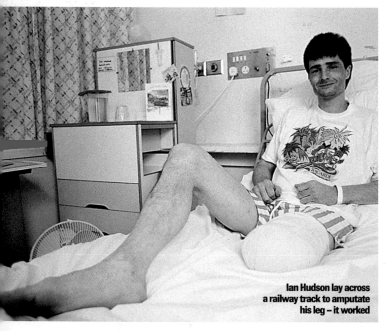

Ian Hudson lay across a railway track to amputate his leg – it worked

First joined forces with psychologist and amputee wannabe Gregg Furth. "Gregg wanted BIID to be a recognised condition, so surgeons would be willing to carry out amputations," says First. "I asked him to help me recruit people for a study by posting a message on internet discussion groups. I was astonished when 52 people came forward." From conducting interviews and group meetings, First discovered everyone had a different story as to why they wanted to lose a limb, and it held a sexual element for only a small minority of the group.

"For a lot of people it's primarily about identity," says First. "They feel like their identity is that of an amputee, and feel awkward having four limbs. They have this idea stuck in their heads since childhood that they should only have three limbs. One thing they had in common was being exposed to an amputee from an early age."

First interviewed George Boyer and another man, who'd deliberately severed his leg in a wood-chipper. "Some people will try anything," he says. "I heard about a guy who rested his leg across a railway track so the train would take it clean off. The most common way is to expose the limb to dry ice for several hours, but even this doesn't guarantee success. I spoke to a lady who ➡

Roger Kaufman
shows off his
lack of fingers

At 74, Roger Kaufman is a self-amputation aficionado

tried to damage her leg this way, and the doctors refused to amputate her leg. She ended up living with a disfigured leg for more than two years."

THE SEVERING SENIOR

One of the people involved in First's study was Roger Kaufman, based in Brooklyn, New York. Roger began his own self-amputation sessions about four years ago, at age of 70. Now, he's running out of fingers and toes. "When I was five years old there was a boy at nursery who had a mitt for a hand. Maybe that's significant," he muses. Separated from his wife in 1995, Roger started to experiment with some home modifications.

"I'd learned some first aid as a boy scout, and figured that if I cut off a toe I could do what I needed to quench the flow of blood," says Roger. "The first time I got all ready, but chickened out, so I took a nap. When I woke I did it right away. I submerged the toe in iced water for five to 10 minutes beforehand to numb the area. I used a mini rubber band as a tourniquet, then carefully placed a chisel on the toe joint and hit it with a hammer. It was like dealing with a piece of wood, it was that numb."

GEORGE BOYER PRACTISED SHOOTING HIS OWN LEG OFF BY FIRING BULLETS INTO A SHOULDERS OF PORK

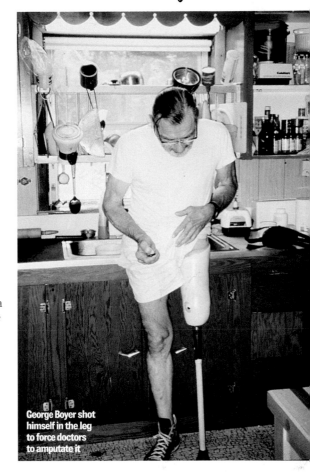

George Boyer shot himself in the leg to force doctors to amputate it

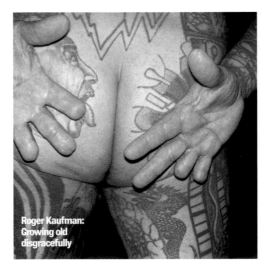

Roger Kaufman: Growing old disgracefully

Encouraged by his first DIY attempt, it wasn't long before Roger took up the hammer again. Several weeks later, he began doing it regularly, taking a bit off here and there. He even had a buddy come over and lop off a toe for him. "Within a year I had no toes on my left foot. The only toe I have now is the big one on my right foot. A man I met online did my middle finger on the right hand. He used a scalpel to get through the joint, and to cut further back he used ordinary garden pruning shears. If you don't stitch up the wound, it could take between six and eight weeks to heal, but if you do stitch it, it might take only two."

BIID doesn't just relate to amputation. Sean O'Connor runs a site called Transabled.org for people with the condition. Since the age of 10, he's wanted to become paraplegic.

"I wasn't very old when I started haunting the public library and the local university's medical library," Sean says. "I was seeking information about orthopaedics, wheelchairs and other apparatus. ➡

THE ONES THAT GOT AWAY...

THIS LIMBLESS LOT WEREN'T LUCKY ENOUGH TO CHOOSE – TALK ABOUT DIY DISASTERS…

In 1993, Bill Jeracki was fishing near St Mary's Glacier in Colorado when a boulder pinned him to a rock, crushing his left leg. With a heavy blizzard on the way, the 47-year-old made the tough decision to hack off his own leg rather than perish overnight. Making a tourniquet out of his shirt, Jeracki sliced though his leg at the knee with a hunting knife, describing the technique as "like filleting a fish". After clamping the bleeding arteries with clips from his fishing box, he was able to crawl to his car and drive to the nearest town.

For Aron Ralston, a hiking trip in Utah turned into a nightmare, after the 27-year-old became trapped when a boulder he was climbing on rolled over and crushed his arm against a rock face. After a day of futilely trying to chip away the rock, Ralston faced the reality of what he had to do. Using a cheap multi-use tool, he severed his arm below the elbow, before crawling through a narrow canyon, scaling a 60ft cliff and trekking six miles to find help.

In 2003, a 44-year-old Australian miner became trapped under his tractor when the vehicle flipped over on top of him. Worried that he'd starve to death before anyone found him, the man decided to free himself and set about severing his arm below the elbow. He was found, having just finished the job, by another worker.

Douglas Goodale took his lobster boat out one fateful morning, but hit trouble when strong winds began building up. A rope became snagged, and, while trying to retrieve it, Goodale's sleeve became caught in the winch, dragging his hand and arm into the mechanism. Now dangling over the side of the boat, the fisherman had to dislocate his shoulder to get himself back onboard and then, using a fishing knife, hack off his mangled arm. Goodale managed to steer the boat back to harbour and get to hospital.

I'll readily admit that at the time I didn't understand what paralysis was, and a big part of the fascination was related to the apparatus. I also didn't have a proper understanding of my own feelings. I just knew I should be paralysed."

Classed as a 'wannabe', Sean pretends to live the life of a paraplegic by using a wheelchair and hanging out with disabled people, but he's deeply committed to sending out the message that Body Integrity Identity Disorder is a disability in itself. "People need to change the way that they think," he says. "It's not 'amputation and other related conditions'. The condition is BIID, and it just so happens that BIID encompasses amputation, paralysis, blindness, deafness and so on. I can't help advocating the inclusion of all 'flavours' of BIID. Anything less is actually damaging to the cause." Asked if being paralysed would suffice, Sean says, "People wonder if being paraplegic would be enough for me, or if I'd go one step further and consider a bilateral femoral nerve

"I NUMBED MY FOOT IN ICE, PLACED A CHISEL ON MY TOE JOINT AND HIT IT WITH A HAMMER"

transection, which would paralyse my legs but not affect my bowels, bladder or genitalia. It's a good question. I think being an L1/L2 (with a loss of movement and feeling in the legs) paraplegic would probably be enough for me."

For Roger, however, the loss of most of his toes and fingers is not enough. "I'd consider losing a good portion of my palm on my left hand as long as I can grip," he says. "One has to establish the boundaries of what is functional and what is not. Getting the pills out of blister packs is pretty hard now. I can use can openers and tie laces, but I do have Velcro shoes. As long as I've got my thumbs I'll be OK. I have no stopping point. I ask myself, 'When will I stop?' and the answer is this – never." ⑬

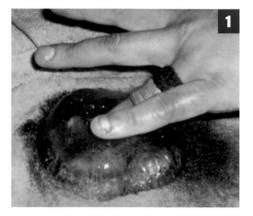

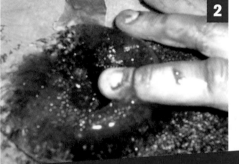

Body Mod Masterclass No.6

NULLIFICATION

BORED OF YOUR BODY? THEN JUST RIP IT UP AND START AGAIN

Nullification is a catch-all term for the voluntary removal of any part of your body. As well as permanent removal, temporary nullification play covers activities such as taping and gluing parts of your body together, wearing chastity devices, or pushing your own body parts inside yourself. Some nullification fans may take the scrotum and glue it over their genitals, or wear mechanical devices to make erection impossible. It's basically disabling any part of your body.

When it comes to permanent removal, body modders will take off pretty much anything. Some people remove their navels or their nipples, and there's even a guy in Philadelphia who chopped off one of his ears and had a crow tattooed in its place on the side of his head. Eric Sprague, better known as Lizardman (see p33), considered having his ears removed a few years ago,

← 4

HOW ONE BME USER REMOVED HIS OWN FINGERTIP

1 The finger was thoroughly numbed on a lump of ice.

2 Although a tourniquet was used to stem the bloodflow to some extent, it wasn't a totally bloodless experience.

3 The digit was then cut all the way round with a craft knife, and came off quite easily.

4 The fingertip was then proudly displayed between chopsticks for friends and online viewers to admire.

One of John's severed nipples...

...which he now uses as natty ear decorations

but decided he didn't want to risk losing some of his hearing. Obviously, the outer ear helps channel sound into your body, so it can negatively affect your hearing if you remove it.

Ears aside, there are people who want to have their noses removed. A BME contributor told us of how a hardcore Satanist friend of his has been bugging Brian Decker (body-modder from Pure Body Arts in Brooklyn, New York) for the past five years to take his nose off. Basically, Mr Satan would like a zombie nose, and wants to cut off the tip at an angle. It's not that hard or difficult a procedure to carry out; the only problem is finding an expert willing to do it.

But while most nullification fans want to completely remove a body part, John Blake wears his removed nipples as a fashion statement. John had his nipples cut off by

ONE SATANIST WANTS HIS NOSE REMOVED SO HE LOOKS LIKE A ZOMBIE

body mod hero Howie (Lunacobra.net) because he "hated the sensation" of them being there, and had the offending teats cast in resin and turned into ear plugs.

The upsides, John says, are having a nipple-free chest. The downsides are that people keep asking him to prove he has no nipples, and women aren't as impressed as he'd hoped. Still, he's planning to get his navel removed, and has a tentative plan to swap part of his finger with someone else's. ⑬

PICTURES: BMEZINE.COM

THE WIFE OF TRANSSEXUAL PORN STAR BUCK ANGEL IS A BODY PIERCING PIONEER AND A WORK OF ART IN HERSELF

WORDS AND PICTURES **ASHLEY/SAVAGESKIN.CO.UK**

ELAYNE *Angel*

*I*f you've got a tongue stud, bellybutton piercing or a pair of tattooed wings on your back, Elayne Angel is the woman to thank. As a piercer she's punched around 40,000 holes through the skin of willing punters, and she's had 40 done on herself. While running the USA's first piercing studio, she also invented and developed various body mod trends and techniques. Previously married to one of the UK's leading tattoo artists, Alex Binnie, she now calls female-to-male transsexual pornstar Buck Angel hubby. We nailed her down for the hole story.

Tell us about your childhood
I grew up in the San Fernando Valley in Southern California – but I was never a traditional Valley girl. I'd dress strangely, but I was a straight-A student. In many ways, I didn't conform. And as a shaven-headed, heavily tattooed and pierced woman, that's probably still the case!

When did you become interested in piercing?
When I was five I begged my parents to let me have my ears pierced, and when I was seven they finally let me. By the time I was 12, I was already piercing myself, and by my early teens I was piercing friends and other parts of my body. ➡

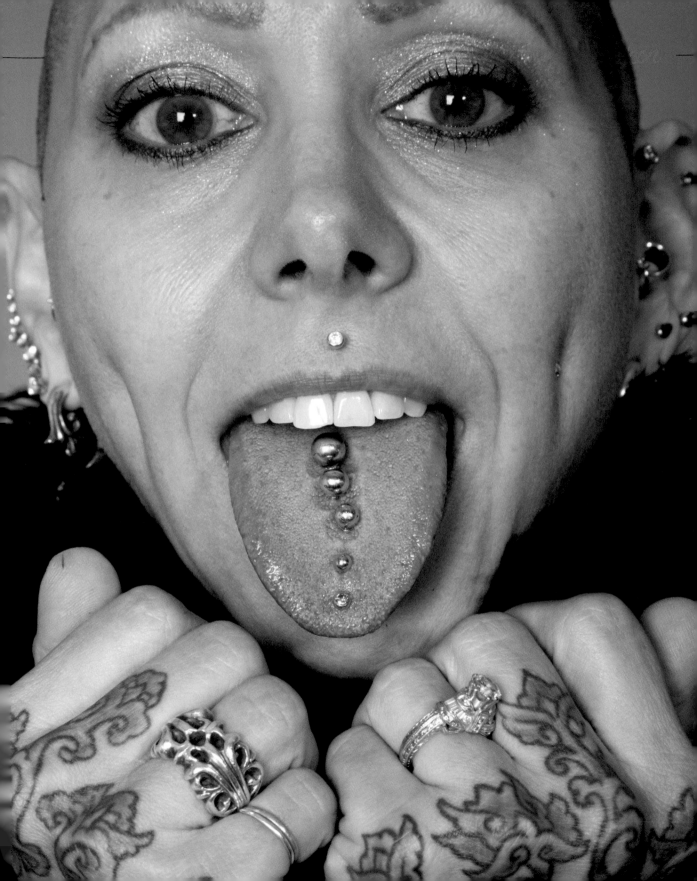

How did you make your hobby into a career?

Once I discovered the New York piercing studio, Gauntlet, things moved on quickly. Gauntlet was started by body mod pioneer Jim Ward in the 1970s, and I started to work there in the 80s. Jim wanted to move back to San Francisco and was planning to close the shop, but luckily someone suggested he talk to me first. So I put on a little business suit and had a job interview. He hired me and went off to San Francisco, leaving me in charge. Gauntlet was the first and only piercing studio in the US at the time.

What was your speciality?

I'm generally considered responsible for the popularity of tongue piercings – I had the first multiple tongue piercing, too. I also named the lorum (a piercing placed low on the penis shaft, near the scrotum), invented the fourchette (a piercing placed at the rear of the vagina), and perfected the female genital piercing known as the triangle (an incision that passes behind the clitoral shaft). Back in those days people didn't even have eyebrow piercings – so all this stuff was new and extreme.

Most of the clients in the early days were from the gay and S&M communities, weren't they?

Yeah, they were the original customers. But when the book Modern Primitives came out (the first comprehensive text about body modification, published in 1989), all sorts of people would show up. We started to get lots of media attention, and I was seen as the studio's friendly female face.

I realised what a positive impact the media could have on the scene. Things really started to take off around then. Then, when the Aerosmith video for 'Cryin'' came out in 1993, it featured a scene where Alicia Silverstone

"I'M AN ADVOCATE OF BEING TRUE TO YOURSELF, WHOEVER THAT MAY BE"

gets her bellybutton pierced. Paul King, one of the guys who worked for me, was the piercer in the video. After that, navel piercing boomed and it's now one of the most popular modifications.

Why did you leave Gauntlet?

A friend died. And that spurred me on to live a little more and see other places. So I travelled all around the USA, working along the way. Eventually, I settled in New Orleans and had a studio called Rings Of Desire for 12 years. Then Hurricane Katrina hit. After that only one employee came back, so I decided to close the studio.

As something of a piercing purist, how do you feel about extreme modification trends?

People consider me primarily as an advocate of body art, tattoos or piercings, but I'm really an advocate for being yourself, whoever that may be. For me, that ➡

Tatt Fact
In 2005, online casino GoldenPalace.com paid Karolyne Smith £6,500 to tattoo their logo on her forehead

WINGING IT

THE CHANGING FACE (AND BODY) OF A PIERCING ICON…

1978

Elayne's sweet and innocent school portrait. Check out the ear, though…

1985

Elayne Angel, BW (Before Wings), strikes a pose in some formidable heels

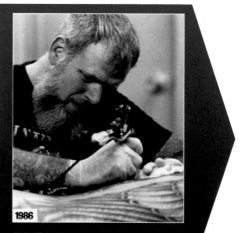

1986

Bob Roberts knuckles down and inks Elayne's beloved angel wings

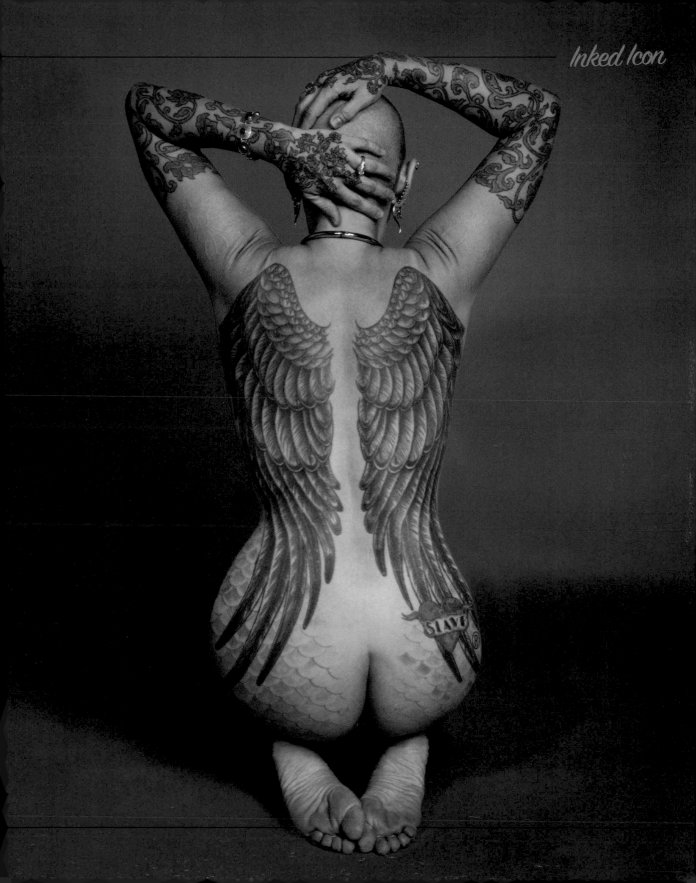

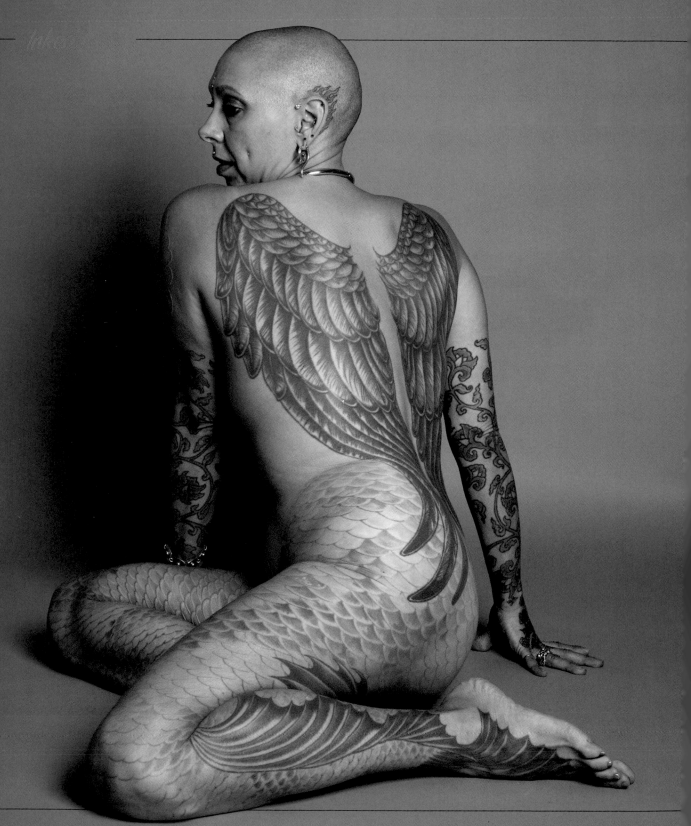

involves having tattoos and piercings, but I also have some scarification through a technique I invented called 'etching'. Some of the more extreme mods people have aren't really for me.

How does etching work?

Etching is scarification done with a tattoo machine and it produces the most precise, even, clean scarring I've ever seen. It's done with the machine but without ink. Part of the process is down to the technique, and part of it is down to how you care for it afterwards – you have to pick out the scab and rough it up. Within the bounds of cleanliness, you have to do everything you wouldn't do to a tattoo to get a good result.

What was your first big tattoo?

The first piece I got was a pair of wings on my back. They were done by Bob Roberts at Spotlight Tattoo in Hollywood, in 1986. At that time there weren't many heavily tattooed women around, so it was quite a full-on thing to do, especially for a first tattoo.

You told me once that your wings are registered.

"WHEN I HAD MY WINGS DONE YOU DIDN'T SEE HEAVILY TATTOOED LADIES"

Yes, with the US Patent Office. They're the first body art or human feature to be registered by that office – my wings are well known, along with my logo. My attorney even recommended I get an encircled ⓡ tattooed as protection, so I did! Sadly, the registration doesn't afford legal protection against someone getting my wings tattooed on their body, but they shouldn't anyway because they're mine, and, as such, should be protected on moral grounds.

How do you feel about copying tattoos in general?

I have a file of photos of people who've copied my wings. I know in some way it's a form of flattery, but I don't really understand it. My wings are so personal to me. Of course, someone else can also want a pair of wings – but why do they have to be exactly the same as mine?

You're working on a book about body piercing. Can you tell us a bit more about it?

There's currently no authoritative guide on body piercing for consumers or people who may need more information about the piercing world – medical professionals, people in the education system and so on. It'll explain, among other things, what infections look like and how they can be treated.

How did you meet your husband, Buck Angel?

We met online. I was in New Orleans, he was in Los Angeles, so it was long-distance for a while.

Did the fact Buck was born female affect your attitude towards him?

Not in any negative way. In fact, there's something more about a man who has lived in someone else's shoes. He's not less of a man – he's just had more life experience.

Anything else you'd like to say about body art?

Many people get body art because they see something they like on someone else – but that's a massive mistake. You have to look inside yourself. If you don't find anything in there to bring out, forget about it. People who get work done because it looks 'cool' demean those of us who have meaningful body art. Oh, and Buck Angel for President! Ⓑ

Tatt Fact
When the Romans invaded Britain, they called the natives 'Picts' because of their tatts and body paint

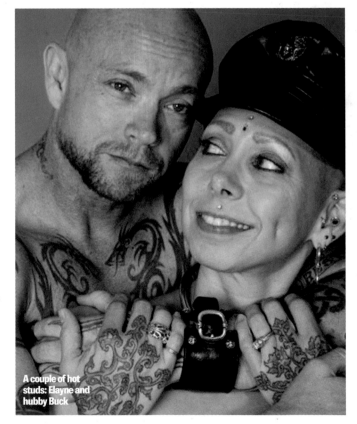

A couple of hot studs: Elayne and hubby Buck

Not everyone thinks tongue mods are strictly internal, but here's a nice spilt one anyway…

Body Mod Masterclass No.7

INTERNAL MODS

Open wide – and that, ladies and gents, is what a split uvula looks like

IMPORTANT!

DON'T TRY THIS AT HOME

IT'S DANGEROUS! IF YOU WANT TO MODIFY YOUR BODY IN ANY WAY, SPEAK TO A PRO

FOR SOME BODY MOD ENTHUSIASTS, IT'S ABOUT KEEPING IT ALL INSIDE…

Although most body mods are created so as many people as possible will see them, others are the complete opposite. In fact, some people choose body modifications that are totally internal.

This isn't a new phenomenon; in ancient Aztec and Mayan cultures, people used discreet implants – generally small beads, invisible to the naked eye – as a special form of protection, implanted in the forehead, arm or whatever area they wanted to safeguard.

The people who get internal mods are usually driven by a different desire than those who opt for traditional body art. In fact, when body mod hero Jon Cobb performed his first uvula piercing (the wobbly bit at the top of your throat), he talked of wanting to "pierce the centre of himself", and make a change to the very core of his being.

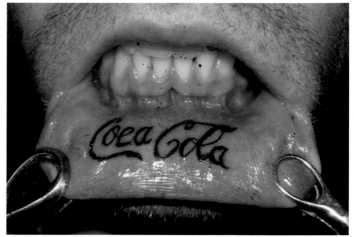

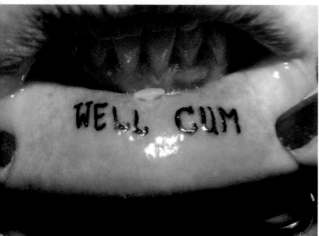

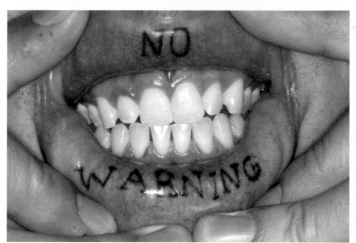

Tongue-piercing is one of the most popular procedures in body modding, and tongue tattoos are also becoming increasingly common. A piercing in the web-like tissue under your tongue is also fairly standard now, and the end result is hidden – there's no reason anyone would notice it. Gum piercings, on the other hand, aren't always what they seem: rather than going through the gum, they often just penetrate the edge.

But while it's debatable if tongue and gum mods are truly internal, inner-lip tattoos definitely fall into this category. And while they're completely hidden inside your mouth, they're often used to convey secret political messages; it's common to see vulgar, confrontational messages tattooed on inner-lips, and police in the USA have learned to look there after an aggressive shakedown to see exactly what sort of person they're dealing with.

BELIEVE IT OR NOT, ANAL TATTOOS REALLY DO EXIST

Anal tattoos are also available. A popular tale on BMEzine.com tells of the amazing design of an inked 'fist' going right inside its owner's anus. Not surprisingly, it's hard to find artists willing to work in such a delicate area – it's fiddly, and they'd have to use a speculum.

In theory, it would be possible to get tattooed directly onto your bones – though it's unlikely you'll find a surgeon anywhere in the world who'd want to do it. And depending on the part of the body, you'd probably be able to feel it; if it was on your shin, for example, it'd be sensitive. And nobody else would know why. ⓑ

ETHEL HALLOW

Age 23.
From Reading, UK.
Who did them? My arms were done by Mark Goddard at Fantasy Fine Line Tattoos, Maidenhead, UK, and my tummy by Alex Simpson at Poison Ink, Basingstoke, and Mark Goddard at Fantasy Fine Line.
What is it? On my tummy are two dead birds among some roses holding a scroll saying, 'Don't let it be regret that falls in your lap'.
Why did you choose it? The words are from a Walls Of Jericho song. Growing up, I did a lot of stupid things. I feel I've paid for those mistakes, and I have a much better attitude now. That lyric pretty much sums up my outlook on life.

BIZARRE'S ULTRA VIXENS *Tattoos*

THE ULTRA VIXENS ARE *BIZARRE*'S HOTTEST READERS. HERE'S A ROUNDUP OF OUR TOP TATTOOED TEMPTRESSES...

COMPILED BY **DENISE STANBOROUGH**

SINMORA

Age 29.
From Cleveland, USA.
Who did it?
David Graham from Studio
X Tattoo, Vancouver.
What is it? The lower chest
piece is a black widow spider,
crawling up into the fire. There
are bats inside the fire on each
side, and I also have male and
female devils on each shoulder.
Why did you choose them?
I chose the spider because
I like the idea that the female
black widow eats the male
after mating, so the placement
between my breasts seemed
like an hilarious idea. I had the
bats to set it off.
What response do you get?
People love it! ➡

HONEY

Age 24.

From Germany.

Who did it? I got my tattoos around the world. Friends and artists who were starting out in the industry did my first ones.

Why did you choose them? Every tattoo I have has a meaning to me.

What response do you get? I live in South America, and here most people still don't understand why people get tattooed. Fortunately, things are getting better every year. Of course, you can't please everyone, but at least I can make more people understand that I'm not a sailor or a prostitute. ➡

LORILEI

Age 25.
From Reading, UK.
Who did it? My tattoos have been done all over the place. My sleeve was started by Rob Hoskins at Idle Hand Tattoo, Cheltenham.
What is it? The idea was to have a mix of old school and traditional tattoos, but with a twist. I love the 1950s and tattoos that go with that era, such as cherries, eight balls, cards and dice, but I wanted them to be a little 'darker' than the stuff you normally see.
What response do you get? Apart from my mother, who regularly begs me not to get any more tattoos, I generally get positive feedback from everyone.

NEENEE

Age 20.

From Staffordshire, UK.

Who did it? My mum's ex-boyfriend, but let's not go there!

What is it? Inverted pentagrams across the bottom of my back.

Why did you choose them? The inverted pentagram is an image that's close to my heart, and holds more than the usual meaning which people associate it with. The inverted pentagram has been a part of my life in many different ways, and is symbolic of my nature. I have another inverted pentagram on my right hip, but you're not seeing that one!

What do your family think? Well, put it this way – my mum has more tattoos than me!

KINDRA RAVENMOON

Age Over 30.

From Montreal, Canada.

Who did it? Gil Crocker at Jolly Rogers Tattoo, Montreal.

What is it? A Nordic tribal image on my arm, but it's also an symbol used by my boyfriend's band.

Why did you choose it? It's completely original, and my boyfriend and I are the only people in the world who have it. Mine is a little different than his, with a small raven outline in the centre. The raven represents the Norse god Odin, and the symbol is for protection, success and love.

What do you think about it now? I love it and always will because it represents meaning and power. ➡

CADAVERELLA

Age 24.
From Vermont, USA.
Who did it? Liz Dye who used to work at Yankee Tattoo, Vermont, did the bat on my chest. Jim DuVal at the same studio did my psycho girl arm piece.
Why did you choose them? I toyed with the idea of getting a bat on my chest that looked more like a psychobilly cartoon, but in the end I decided I wanted one that looked more realistic. Bats are amazing, and they're cute too! The other piece on my arm is of a psycho girl — that's me! — cutting up her dollies and sewing the parts back together to make a better one, all covered in blood and gore! The teddy in my tattoo is getting a full autopsy.

KAYLEIGH KITTIFUR

Age 20.
From Richmond, UK.
Who did it? My own daring self.
What is it? An arm of bizarre images that I love and cherish.
Why did you choose them? Because I want everyone to know how cool I am!
What response do you get from people? I get funny looks, and lots of free drinks.
What do your family think? My family love my art. I think they're jealous, actually.
What do you think about them now? I want more, more, more!
What other ink do you have planned? You'll have to say tuned to find out!

QUEEN VEE

Age 19.
From Manchester, UK.
Who did it? Ray's Tattoos, Wigan.
What is it? A koi carp.
Why did you choose it? I wanted something that went with my body shape, and this design was perfect!
What response do you get? People ask if it hurts to get your ribs tattooed. The answer? Yes!
What do your family think? They aren't that keen on tattoos, but each to their own.
What do you think about it now? I love it! I now have another koi on the other side of my stomach.
What other ink do you have planned? I'd like to get a Mexican Day Of The Dead skull. ⑬

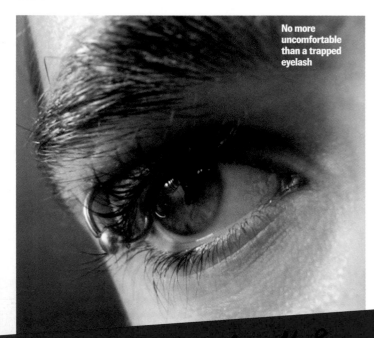

No more uncomfortable than a trapped eyelash

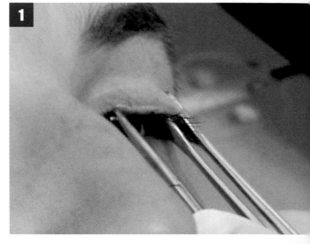

1

A close-up of some eyelid skewering

Body Mod Masterclass No.8
EYELID PIERCING

IMPORTANT!
DON'T TRY THIS AT HOME

IT'S DANGEROUS! IF YOU WANT TO MODIFY YOUR BODY IN ANY WAY, SPEAK TO A PRO

ONE EXTREME WAY TO ACHIEVE THAT SEXY, HEAVY-LIDDED LOOK...

Ask most people which part of the body can't be pierced and 'eyelids' would be high on the list. But expert body modders have found a way to pierce eyelids successfully. And while the procedure is still far from common – and is only behind cervix piercing in terms of rarity – the procedure is growing in popularity with members of the hardcore body modding community.

Joe Amato of Tatts Taylor Tattoos in Fort Lauderdale pierced his friend Kevin's eyelid. Joe used a small set of sponge forceps with the grips polished off to hold Kevin's eyelid in place, so as not to damage the inside. For the actual piercing he used handmade needles, under 13mm long, to pierce from the inside of the lid.

Kevin says the piercing was uncomfortable immediately afterwards and during the first night, and

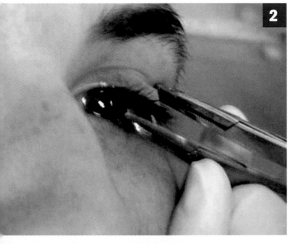

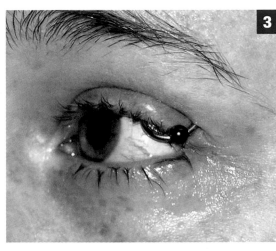

GETTING YOUR EYELID PIERCED

1 A small set of sponge forceps are used to hold out the eyelid.

2 The piercing is done usinghomemade needles, to avoid over stretching the subject's eyelid.

3 The finished piercing is irritating for the first few days, but any discomfort soonpasses.

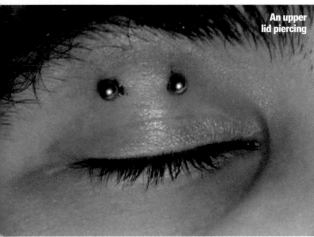

An upper lid piercing

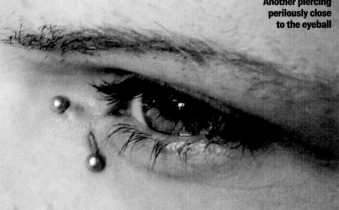

Another piercing perilously close to the eyeball

that the next morning it was "pretty swollen, uncomfortable, and slightly annoying". However, once his eye dried out, the pain subsided. Kevin rinsed his eye three times a day to remove any debris using H20cean saline spray; this liquid has a salinity as close to tears as you can get, so there was little danger of his eye sustaining any kind of damage from external matter.

He also took a zinc supplement, which is a common method of speeding up the healing process, as well as a painkiller to help to reduce the swelling. On the second night Kevin had trouble sleeping, and when he woke up the next morning there was "a large amount of pus" under his eyelid. But he cleared it out with H20cean and a cotton bud and it didn't happen again.

Kevin's eyelid was swollen and bruised for a few days, and it was mildly painful to close the lid completely or

IT'S JUST LIKE HAVING AN EYELASH CAUGHT UNDER YOUR EYELID

open it wide. He described the sensation as "like having an eyelash caught under the lid" – irritating but bearable.

By the end of the week, Kevin said he felt completely used to the piercing. He uses H2Ocean several times a day to stave off infection, as well as eyedrops when necessary.

The modification hasn't caused Kevin any problems with his vision. In fact, he says the only problem he's had is standing in lifts with people who suddenly notice his piercing, then shrink away in horror. **B**

THE REST

MORE AMAZING INK SENT IN BY THE READERS OF *BIZARRE*

LEILA

Who did it? Albert from Southend-on-Sea, UK.
He owns a shop, but isn't on the internet.
The design was done freehand.
What is it? Wings on my back.
Why did you choose it? I gave Albert a vague
idea of what I wanted and let his imagination
run riot. It's a reminder that I'm capable of
anything, and can fly in the sky that is life.

JOE 'JOECEPHUS' KILLINGSWORTH

Who did it? A guest artist called Dimitri
at Underground Art, Memphis, USA.
What is it? Johnny Cash giving the finger.
Why did you choose it? A picture is worth
a thousand words, and this image says it all!
What response do you get? Because it's Johnny
Cash, it gets nothing but love from everybody.

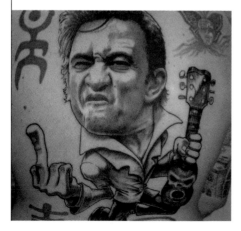

REBECCA WOOD

Who did it? Lisa at SlimShader, Toddington, UK.
What is it? A tattoo of wings on my back.
Why did you choose it? To me the wings symbolise freedom and being able to fly away and go anywhere you want. More specifically, they symbolise the freedom to be who you want to be, without people judging you just for being who you are.

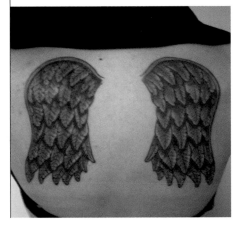

PHILIP GREEN

Who did it? Bez, Triplesix Studios, Sunderland, UK.
What is it? The Joker as played by Heath Ledger. It's part of a big graphic novel piece.
Why did you choose it? I'm a big fan of graphic novels and Batman, and came up with the idea of having the Joker on my back and Batman on my front. This has now developed into a bigger piece, which will be graphic novel pages on my arm.

SHELLY LALLY

Who did it? Mostly by Gavin at Feline Tattoo Studio, Sheffield, UK.
What is it? A collection of tattooed oddments representing some of my obsessions, including 1950s motifs and cocktails. Especially cocktails.
What response do you get? Some people say it looks like a collection of fridge magnets, which is fine by me as I collect them too! ➡

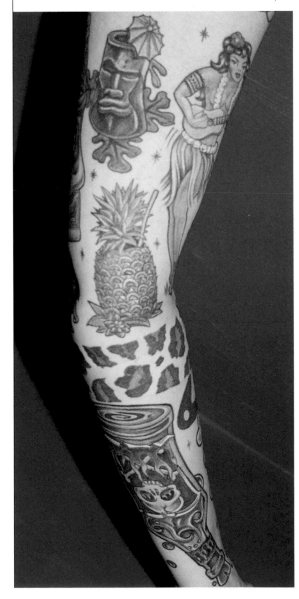

COLIN PECKHAM

Who did it? Darren Smith.
What is it? A battle scene from a fantasy world, all done completely freehand from the tattooist's imagination.
Why did you choose it? I'm a big fan of The Lord Of The Rings books, and wanted a tattoo on my back that looked the way I imagine the characters to look. I also enjoy being tattooed!

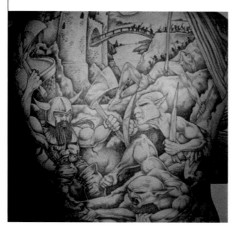

DERYN

Who did it? Me, under the name BodyVandal, at House Of Pain Tattoo Studio, Manchester, UK.
What is it? A swastika flower.
Why did you choose it? Geometric shapes and patterns rock my world, and my body. There's nothing I love to do more on my days off than grab some needles and ink and poke away.
How do you feel about it now? Frickin' love it!

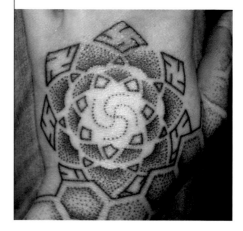

LILY TANG

Who did it? Monica Henk at Pure Body Arts and Lalo at Sacred Tattoo, both in New York, USA.
What is it? A Maneki Neko (Japanese lucky cat) surrounded by orchids.
Why did you choose it? My grandmother, who I visited often as a child, used to have tons of them in her Chinatown apartment. She passed away when I was nine.

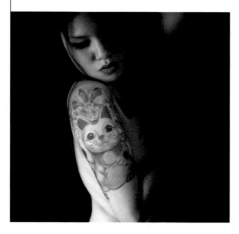

HANAH CRAVEN

Who did it? Adam Sage at Into You Tattoo, Brighton, UK.
What is it? Tibetan Buddha eyes on my feet.
How do you feel about it now? I love it now, but was walking like I'd shat myself for about five hours afterwards! However, the healing process was quick and I was walking fine the next day because the work was done by hand.

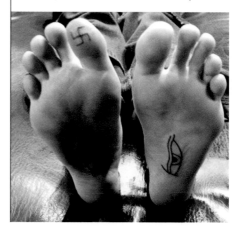

ALEX

Who did it? My facial tribal tattoos were done by Freewind from Los Angeles, USA and Spike from Wolverhampton, UK. My bodysuit was inked by various artists across the world.

What is it? The jigsaw bodysuit was inspired by The Enigma, a former member of the Jim Rose Circus.

What response do you get? Mixed reactions!

JAMES ELPHICK

Who did it? A Buddhist monk who goes into trance and is inhabited by the 2,000 year old spirit of a magician named Por Gae.

What is it? It's called Hanuman Sak Yant. In Indian folklore, Hanuman is the immortal monkey god. Sak means 'to tap or tattoo', and Yant comes from the Sanskrit word 'yantra' – a geometrical symbolic representation of the Hindu gods.

CARRIE LEFLER

Who did it? Jeff Page at True Tattoo, Los Angeles, USA.

What is it? A pocket watch and a rose.

Why did you choose it? To remind me to stay in the moment and not dwell on the past or future.

What response do you get? People like the significance of the time on the watch – it was the exact time Jeff started the tattoo. 🅱

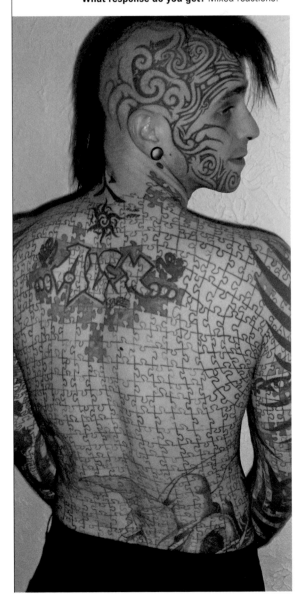

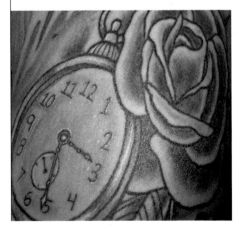

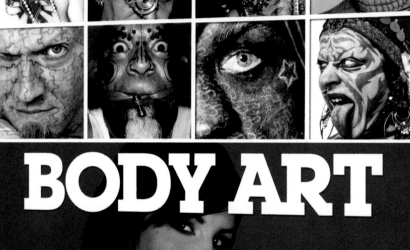